A
Witch's
BESTIARY

Dedication

This work is dedicated to Baza Novic for his support & inspiration
To my two children Momoko & Namiye & my Mother Denise for their
unending excitement and enjoyment of the Mythological Beasts.
And to Loki, the Beast of Adam Parfrey who passed while I was working
on this volume. A wonderful creature, whose presence connected all that
came across him to his lovely sentient animal soul.

During completion of this work, my dear friend Adam Parfrey whose kind
agency permitted its creation passed on. I am certain he was greeted by his
familiar spirit Loki the dog who made ready his passage. This book comes to you
with deep gratitude in honor of his life and work, and appreciation for his
decision to include my research in his efforts. We will all miss you Adam,
Thank you for remaining true to your Feral Beast!

A
Witch's
BESTIARY
Visions of Supernatural Creatures

BY
MAJA D'AOUST

PROCESS

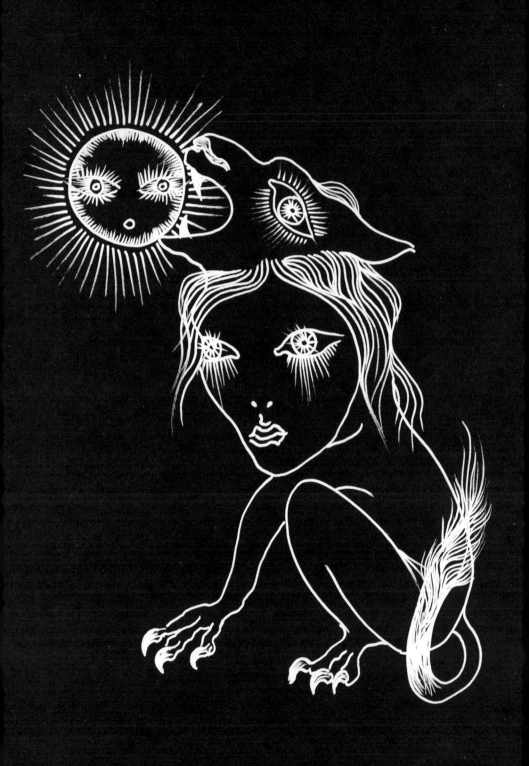

INTRODUCTION

"Gorgons and Hydras and Chimeras,
dire stories of Celaeno and the harpies
may reproduce themselves in the brain
of superstition but they were there before.
They are transcripts, types, the archetypes
are in us and eternal these terrors
date beyond body or, without the body,
they would have been the same."

—Charles Lamb,
WITCHES AND OTHER NIGHT-FEARS

The Tradition of the Bestiary extends far back into antiquity. Humans have always been interested in cataloging and exploring the Natural environment. Ancient religious texts tell of a primordial Human who named all the living creatures and plants of the Earth, hiding in their names knowledge of their attributes and powers. The Bestiaries and Materia Medicas seek to mimic this action by identifying traits and abilities much like the initial naming day in the Garden of Eden. Occultists, Magicians, Monks, Shamans and Scientists have made tomes relating correspondences based on qualities and affiliations to compile knowledge of both Earthbound life forms and the stars and planets above. This information was used for healing and medicine as well as for religious and spiritual purposes. One of the things that has always been pronounced in the ancient Bestiaries are the fantastical creatures that seem to find their way into almost all of them.

The prototype that most bestiaries are based on is a work called the *Physiologus* from Alexandria around 200-400 A.D., which does contain mythological animals. It is a Christian book that has allegories and moral lessons included for all the creatures in a very Aesop's Fable type of style, and clearly borrowed heavily from these earlier animal tales which dated to Greece around 500 B.C. We also have the enormous work of Ovid's *Metamorphoses* which focused on the hybrids and imaginary beings dating several centuries prior to the *Physiologus*. Pliny the Elder's work *Historia Naturalis* had a huge influence on later renaissance versions of the Bestiaries and was also a bit earlier, closer to the time of Ovid.

Modern-day scientists have long puzzled over these old books that so carefully and thoroughly record in painstaking detail the animals we live with, but then go on to give the same attention to a bunch of imaginary or mythological creatures, including them in the mix. How could the same books that displayed correct data on very real animals take seriously a clearly constructed beast such as the Griffin? Somehow, these historic reporters must have either believed in the stories of the existence of such beings or they had seen them themselves. There is another option though: the extraordinary Beasts recorded in the Bestiaries that can't be found readily around us might just exist and not exist simultaneously. They might be very real, and not real. It could be that there are places these creatures do exist that are outside our perceptual reality. After all, some of them are counted in the heavens in the constellations of the stars that have existed long before and and will exist long after us in the grand scheme of things.

Some argue the fantastic animals exist buried deep within the dark folds of the subconscious minds of humans. Others say there are perfectly reasonable explanations for all of them such as dinosaur fossils or misunderstandings. Still others debate about the supernatural places that might be tucked into our own realities like creviced portals into Narnia where these creatures live.

Whatever the answer may be to the wonderful conundrum of the hybrid forms of the animalistic totemic superbeings, they will not be losing their hold upon the Human psyche anytime soon.

In my contemplations of the Beasts, it became clear to me that many of the mythical creatures are considered to be Gods, Supernatural Guardians or Demigods in the forms of animals or human hybrid animals. They are ancient and powerful and we can't stop talking about them over thousands of years. Some had vast cults like the cult of Dagon that worshipped hybrid Fish-men. India, Egypt, Sumeria and most Native cultures all had hybrids and monsters in their Pantheons. The Animal imbued with spirit that is the Mythological Beast forms a part of our collective identity and some of our oldest memories through stories as human beings.

I came to the conclusion that a Bestiary of supernatural creatures is an autobiography of the ancestry of humanity because these are stories that have passed through more generations than our family bibles could even imagine. Enter into the timeless space that is the land of the beasts, where they are real and not real for millennia in the minds of us all every time we think of them.

TABLE
OF CONTENTS

Introduction v

Dragon 1

Baphomet 11

Pegasus 17

Giants 25

Cyclops 33

Griffins 41

Cherubim 47

Demon 53

Golem 61

Chimera 69

Phoenix 77

Oannes and the 85
Fish People

Minotaur 91

Juggernaut 97

Basilisk 101

Centaur 111

Unicorn 117

Werewolf 123

Cerberus 131

Vampire 137

Manticore 147

Apocalypse Beast 155

Epilogue 163

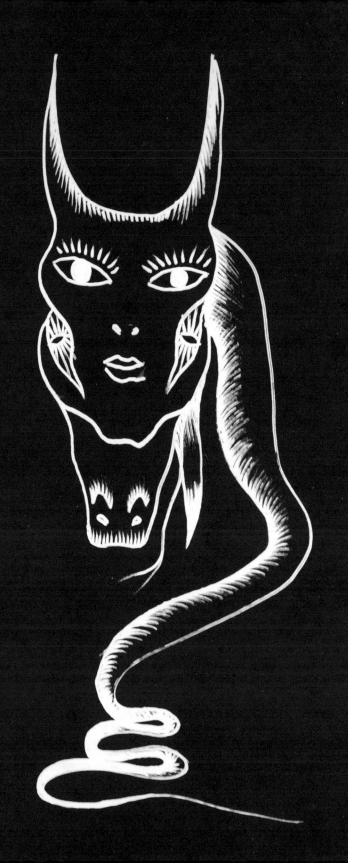

DRAGON

"We are ignorant of the meaning of the
dragon in the same way that we are
ignorant of the meaning of the universe"
—Jorge Luis Borges,
THE BOOK OF IMAGINARY BEINGS

There is a beast that crosses into all the elements and environments, adapting to each one in turn. It is the Dragon. Found in water, fire, air and earth, this ancient form makes all the world its domain. The Dragon is the Primal and first Beast from whom all beasts are born. The Dragon lingers long in the minds of those whose imaginations are captured by it. Pervasive and terrifying, the concept of a huge reptile is a favorite myth of Humanity. Although there is so much Dragon business going on in the minds of humans, it is hard to pinpoint exactly what a Dragon is. The common theme seems to be a large reptile, but from there we see serpents, water serpents, serpents with wings, two-legged serpents with wings, four-legged lizards with wings, four-legged lizards without wings, some with horns and some with no horns.

The Dragon is one of those mythological creatures who certainly could have truth to its existence, since there actually were giant reptiles who roamed the Earth. In terms of a fantastical creature it did exist in the past in the form of the Dinosaurs. Of course, according to modern Science, Dinosaurs never existed at the same time as humans, though this is a topic of hot discussion among cryptozoologists. In recorded Western history, Dinosaur fossils came into popular knowledge in the 1700s but that does not mean no one found them before then. For thousands of years Chinese medicine has used a remedy called "Dragon Bones" which are

fossilized remains, sometimes of dinosaurs, so perhaps they had an awareness of giant reptiles long before the modern scientists stumbled upon them.

The name Dragon, according to some, is literally interpreted as "Serpent" which as a descriptive term means to crawl or creep on the ground. That interpretation would implicate a dragon has no legs, and is more like a snake. The serpent translation gave the Dragon an alter ego throughout history because this title was also used to describe Satan in the biblical literature, so here a connection is formed to the infamous adversary which can be seen represented throughout Judeo-Christian art. The Devil as a Dragon is in depictions of Bible scenes all over Europe. All the famous artistic works of the knights in shining armor fighting the dragons can be compared to the armored Angels attacking the devil. In the Book of Revelation, we see the dragon and Satan directly correlated.

Then there is a variation of the interpretation of the word Dragon from the Greek "Drak" or "Draco" which is more like a Sea Serpent or gigantic reptile. This word places the Dragon as a water creature. The other meaning of the word if we search through etymology means "to see clearly" or "to see"; this comes to us through "Dereksthai" and means an evil eye, or a compelling mesmerizing stare. This version might seem confusing unless one has studied ancient astrology and astronomy. In esoteric Egyptian literature the Dragon's eye was the pole star at the time of some of the early Pharaonic kingdoms and so the entire Universe seemed to rotate around the eye of the drag-on found in the constellation of Draco, the huge serpent in heaven. Currently the pole star has shifted to a nearby location in Ursa Minor hugged up against the body of Draco, but if one is aware of this earlier phenomenon, the importance placed on the gaze of the Heavenly Drag-on is apparent since it was a tangible central force in the rotation of the stars and the measure of the seasons. If not directly associated with an eye of a dragon in the stars, the pairing of the Dragon with Vision

or sight is more esoteric and represents a yogic and spiritual technique that involves fixing the gaze and stilling the eyes. Such Techniques are discussed in indigenous cultures and in the Shiva yoga practices.

Due to the wide variety of Dragon forms, we can divide this creature into a few categories: the Serpent, the Winged Serpent and the Horned Dragon.

First, let's examine the Serpent form of the Dragon.

In Alchemical references, the serpent Dragon represents the primal, or more specifically, the prima materia, a beginning substance that forms all things. It is red, dark and old, often referred to as the base or mother, which takes on a writhing form. Jung calls this the "instinct" or reptilian part of our subconscious minds. In Norse mythology this is the serpent at the base of the tree, hidden deep underground, and many compare this version of the Dragon to Kundalini energy contained at the bottom of the spine. In Sumerian origins of the suffix in Dragon we see it explained as "Gon" or "Kun"; this can mean "Twisted," or "conjoined." This form coils around itself and moves until a foam is created and from this foam life is born. This is called Leviathan in the Bible, a coiling writhing form locked deep in the depths of darkness. In Hebrew the word used is "Tannin" which means "the encircler." In this type of Dragon reference we also come across the symbolism of the Ouroboros, or the encircled serpent, the snake that eats itself and consumes its own tail, forever making a wreath or circle of itself. According to some, the serpent form of the Dragon is the subconscious mind which lays sleeping below the surface of our awareness, emerging into the light only when we dream.

With the idea of twisting and conjoining snakes, we find one of the most popular representations in the Hermetic literature of knowledge. When two serpents interpenetrate and rise up gaining wings, what is formed is called the Caduceus. Seen at most Doctors' offices,

the Caduceus is the second form of the Dragon which is the winged serpent. Contained within the symbolism of the winged serpent we have a thing that creeps and crawls upon the ground that is suddenly lifted up into the sky, connecting Heaven and Earth to each other in an embrace.

The Winged Serpent moves into the air and fire elements as the reptile raises up off the ground and out of the water. Here, the Dragon takes on a role of a go-between in the worlds of Gods and men and is a wisdom keeper. This flying serpent of fire has a name that the Hebrews called "Seraphim" or "Fiery Serpent" and is known as a type of angel. The Seraphim angels are those who deliver messages of God to humans and are considered synonymous with the archangels. Some people even place the origin of the word Angel with the Ancient Indian Rishi named "Angiras," a god of fire whose children were fire serpents. Dragons have long been held to have Fiery breath, but these kinds of dragons are literally made from fire and exude light from their bodies, not just from their breath.

In pre-Judeo-Christian history we see this Dragon of fire in the Hermetic sources. Here, Hermes or Thoth gets all the knowledge of civilization and humanity from a Fiery Serpent creature called Poimandres. Herodotus also wrote at length about these flying serpents from Egypt and Arabia. In Egypt and Africa the winged serpents were called the "Oph," "Apophis" or "Ob." There were many tales of huge serpents in Africa, and the entire country of Ethiopia is rumored to have been named after them. Originally "Aith-Ophea," the name meant fiery serpent, much like the Dragons described by the Greeks. In this form the serpent or Dragon is no longer an adversary, but an ally that confers gifts to Humanity. Or at least those who recognize it as such. The confusion over blaming the serpent for being evil is rectified in this archetype as it is raised to a helper and healer:

"At times, the serpent appears evil but is in reality good. In Shelley's 'The Revolt of Islam,' the snake is presented as the spirit of good making its way over the earth and being abused because mankind does not always discern what is good and what is bad…darkness prevailing over the world gave evil an opportunity to grow strong, develop wings casting ominous shadows. The spirit of good however stayed on the earth in the form of a serpent; and the great spirit of good did creep among the nations of mankind and every tongue cursed and blasphemed him as he passed; for none knew good from evil"
—Lura & Duilio Pedrini,
SERPENT IMAGERY & SYMBOLISM

Lastly there are the Dragons with Horns. These Dragons are hugely popular in China and a great reverence is placed on them. Although they also have the other kinds of dragons, the Horned dragons are thought to be more evolved. The Chinese called them the Qiulong, although this also meant Hornless Dragon confusingly enough, and also meant to curl or writhe around, like the Leviathan. The horned Dragons of China were very serpentine and had long thin bodies, sometimes with legs and wings, and other times without them. In China these Dragons are the ancient Kings of heaven and are venerated as immortal beings who have overcome time and space.

In Native American legends and myths, the Horned serpent is a very important spiritual creature that inhabits the lakes and rivers. It is said to confer wisdom and the holy spirit on those lucky enough to come across it. Horned serpents are found described in multiple tribes all over the country, and some say these can be compared to the "Nagas" or horned serpents described in the rivers of Thailand, Indonesia and India. These serpents can sometimes take the form of a human, or shift

into a flying creature and have supernatural powers and abilities. They also have a strange effect on the weather, able to produce storms on a whim. Winnebago tribes call their horned serpent Waktchex, and it was known to give its seekers profound wisdom of the spirit world.

In Babylonian mythology, the deity Marduk rode a horned dragon when he defeated Tiamat. Tiamat was more like the first type of Dragon, the primordial Leviathan serpent who was the mother to all other things, including Dragons, who is then vanquished by the hero riding upon a horned serpent. The other figure often shown riding a horned Dragon is Kuan Yin as they float across the sea. Kuan Yin is able to mount this serpent because she has gained mastery over her emotions and thus the serpent carries her like a force to wherever her will wishes. One of the most famous horned dragons is in the Book of Revelation where the multi-horned dragon is described as being ridden by a woman, rather like Kuan Yin until it is destroyed by the hero who rides in and slays it just like Tiamat was slain:

"And I saw an angel coming down out of heaven, having the key to the Abyss and holding in his hand a great chain. 2 He seized the dragon, that ancient serpent, who is the devil, or Satan, and bound him for a thousand years. 3 He threw him into the Abyss, and locked and sealed it over him"
—*REVELATION 20*

When viewed through the Alchemical lens, if the Dragon were to represent the subconscious process, it would seem the task is to take the primal form of the Dragon, the serpent, and evolve into a creature that is higher up on the chain. This would be a story of evolving the human mind from its primal form into something more elevated and aligned with Heaven, instead of a thing that crawls upon the Earth. The Dragon is the only creature that is at both the beginning and the end

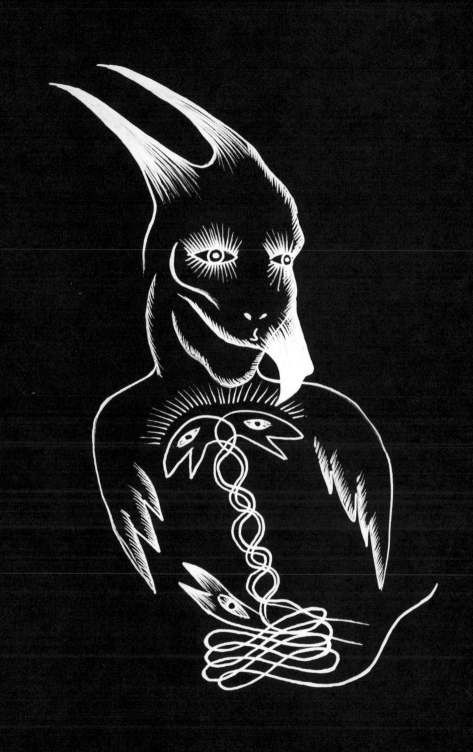

of the Alchemical process, being the unifier of the entire operation. The Dragon is what neatly ties everything together in an Ouroboric ring. It is a Horned serpent that defeats the initial primordial sea monster beast of a Dragon. A Dragon defeats a Dragon on the ever spinning wheel. Once the Horned Dragon aspect of this beast is accomplished by the Alchemist, and the Mother or writhing Leviathan serpent is raised up, the Dragon can be said to symbolize an enlightened Human Being as well as a primordial monster.

"Psychologically, this means that the union of consciousness with its feminine counterpart, the unconscious has undesirable results to begin with: it produces poisonous animals such as the Dragon, serpent, scorpion, basilisk and toad. Then, the lion, bear, wolf, dog and finally the Eagle and the Raven. The first to appear are the cold-blooded animals, then the warm-blooded predators and lastly birds of prey or ill-omened scavengers...but that...is only because there is an evil darkness in both parents which comes to light in the children."
—Carl Jung, *MYSTERIUM CONIUNCTIONIS*

When all of these Dragon forms are combined together into one being, the coiled serpent at the bottom, or hell; the raised fiery serpent with wings in the middle, or the go-between; and the horned dragon at the top, or heaven, it looks suspiciously like another mythical beast in Occult literature: Baphomet.

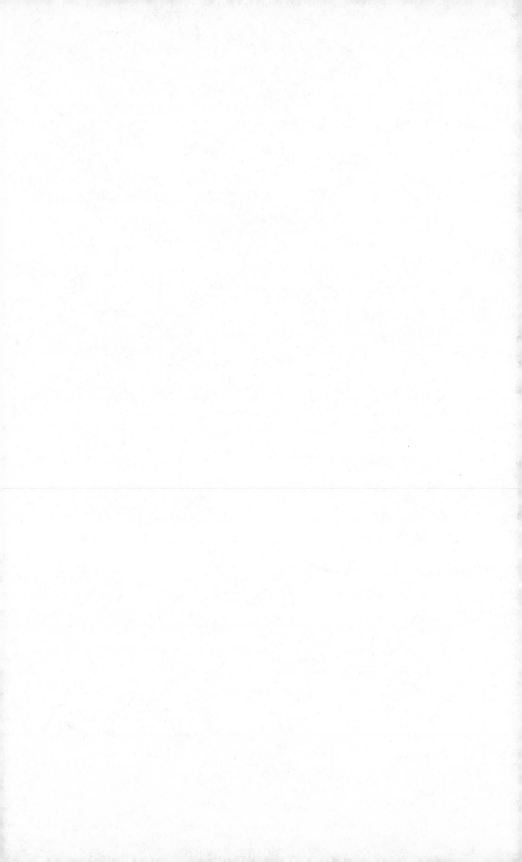

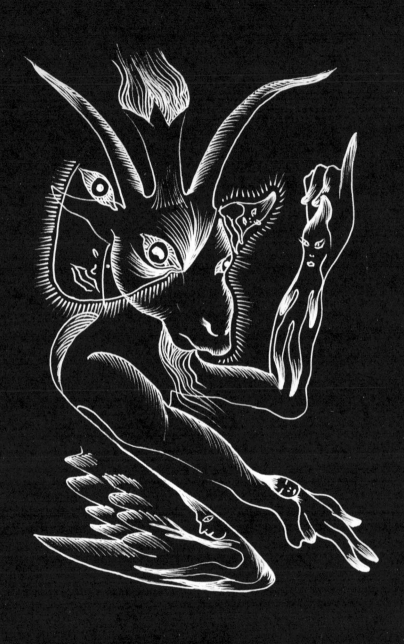

BAPHOMET

"She readied herself for sight of its face.
She had it too, but from inside the flame, as
the creature there—not dead, but alive, not
Midian's subject, but its creator—rolled
its head over in the turmoil of flame and
looked her way. This was Baphomet. This
diced and divided thing. Seeing its face,
she screamed...A thing beyond things.
Beyond love or hatred or their sum, beyond
the beautiful or the monstrous or their sum.
Beyond, finally, her mind's power to
comprehend or catalog."

—Clive Barker,
CABAL

There is a very ancient secret contained within the much maligned form of the Goat-headed Baphomet. I was lucky enough to stumble upon its discovery, which arrived only after years of studying and researching this creature. I hope that my research here is taken with an open mind and not an eye for Blasphemy from religious advocates. Baphomet is one of the most famous icons of the occult, being appropriated and interpreted by thousands of people from many walks of life. From satanic to sacred, Baphomet plays a lot of characters in the world of magic. For me the meaning of Baphomet was made quite plain and simple through an investigation of the name.

If you research Baphomet in the sources available, you will find the same basic answers everywhere. You will hear the tale of the Knights Templar, of strange pagan Goat Gods, and of witches claiming it as Pan. But I would like to present some different findings to be considered.

Most sources agree that the name Baphomet comes from a corruption of the name "Mohammed," also written "Mahomet." This is the Prophet of Islam as told by the religious text the Quran. When we look into the meaning and interpretations of the name Mohammed, we find it means "praiseworthy," but this word also means something more specific: to shine or flash forth light indicating God's favor. So in other words, not just praiseworthy, but really kind of shining like a gold star. In Hebrew too, the word "to praise" is synonymous with shining with light. Hallal is a primary Hebrew root word for praise. The word Hallelujah comes from this base word; it means to praise, to shine, to boast, or celebrate. There are many passages of the Quran which describe Mohammed as a shining lamp, or illuminated lamp whose face shines with light and light pours out of his mouth.

This meaning "to shine" and "to praise" became confused with "horns" in the Hebrew translations, and this is where I believe the image of Baphomet with its mighty horns arose in connection with Mohammed. I discuss this in my work with Adam Parfrey called *The Secret Source* in the chapter on Horny Angelic beings. There were several people other than Mohammed who were described as having this shining face of praise; one of them was Moses. In a possible mistranslation of the Hebrew word "to shine" or "praise" known as "KRN" or Keren, sometimes Qaran, it was written as "horns." Michelangelo made a very controversial statue of Moses in which he is shown with Horns upon his head; most think this is due to the confusion of the translation of the shining face. Compare this horned statue of Moses to the vision of Baphomet.

"Moses came down from Mt. Sinai...
Moses did not know that the skin of his face shone
because he had been talking with God. When Aaron
and all the Israelites saw Moses, the skin of his face was
shining, and they were afraid to come near him."
—*EXODUS 34:29-35*

The horns could be no accident at all upon further inspection and
could be a hidden secret. In the Bible, this same word "to shine" is
also used to describe a horn lifted to the sky, to make things even more
confusing. In Jewish tradition they use the horn of a ram, referred to as
a Shofar, and lift it up which is a symbol of "to praise" much like the
meaning of the name Mohammed. Somehow, raised Horns of a Ram
and a shining face of light are indicators of divinity. Sounds downright
Luciferian. The raising of the horn to heaven is referred to as the "le-ha-
rim ke-ren," which literally means to "lift up a horn." It is mentioned in
the Psalms in relationship to giving Praise in relation to raising a horn
of a Ram. Could it be that the Goat-headed Baphomet is just a symbol
of the ancient tradition of the raising of the Horn in praise of God and
nothing at all related to the Satanic affiliations so many law-abiding
Christians have placed upon it in their own ignorance of ancient Jewish
and Islamic scripture?

"He also exalts the horn of his people, a praise for
all his pious ones, for the children of Israel,
a people near to him. Praise the Lord!"
—*PSALMS 148:14*

In another odd occurance in the Quran there is a story of a great leader
called "Dhul-Qarnayn," which translates as the "Two-Horned One"
whom Allah revealed to Mohammed. The story describes a man to
whom Allah gave great power, and he saves humanity by erecting a
wall to separate the nations of Gog and Magog from humans. Gog and

Magog were Chaotic entities that spilled over the wall during the apocalypse and were later defeated by the Messiah. Most scholars identify Dhul Qarnayn as Alexander the Great, who came to be pictured as having ram's horns on his head after he discovered the tablets of Hermes in Alexandria. It was after Moses is given the Tablets of the Torah that he receives the horns on his head as well, making some kind of indication that when you receive tablets from a divinity you get horns on your head. Many attribute the horns on Alexander the Great as being appropriated from Egyptian gods such as Ammon, Kneph and Hathor.

The Horned Goat head of Baphomet is brought into another perspective under this history of the praised shining prophet of Mohammed and the many others who have been described using this term. The representation of this deity might not be depicting any specific entity at all, it might just be trying to show what happens to Human Beings after they see God. Instead of showing a halo over the head, like in many of the other religious representations of spiritually enlightened beings, in the image of the Baphomet, the horns raised above its head are showing the favor of God upon the soul of this creature who has attained the audience of Heaven. The poor beast Baphomet seems so much less evil when we consider these findings.

Mohammed could also not be a particular individual under the definition of this name in this way. For there are quite a few single people described other than Moses who also met with this praiseworthy phenomenon of a shining face.

The patriarch Enoch is also described with a glowing visage after seeing God. The Original Human, Adam Kadmon, is also depicted in this fashion:

"The Splendor of Adam's face was only one of seven precious gifts that God gave to Adam before the fall.

Some of the others were eternal life, tallness of stature,
the fruit of the soil, the fruit of the trees, the luminaries
in the sky, the light of the moon, and the light of the sun.
The reason that Adam's face shone so brightly is that
God created Adam in his own image (Gen. I:27).
So brightly did his face shine that the angels mistook
him for God himself. So God put him in a deep sleep,
and the angels realized he was no more than a man."
—Howard Schwartz,
TREE OF SOULS: THE MYTHOLOGY OF JUDAISM

It seems this phenomenon was not isolated to Mohammed, although that might make many Muslim people disagree with me; it certainly was described in other individuals who also took the horned form of Baphomet.

If we are to look for a moment at the pagan side of things and the claims of the goat worshipers, we find that the main goat god "Pan" usually ascribed as the identity of Baphomet was named "Faunus" in older references. The original meaning of Faun, or Faunus as argued by some scholars, is "to favor" or to find favorable or firm. This is entertaining since the word favor also meant to praise, much like Mohammed. Here the name Mohammed shares a meaning with the ancient pagan god.

"Son of Amram, fear not! For already God favors you.
Ask what you will with confidence and boldness
for light shines from the skin of your face
from one end of the world to the other."
—*DEAD SEA SCROLLS*

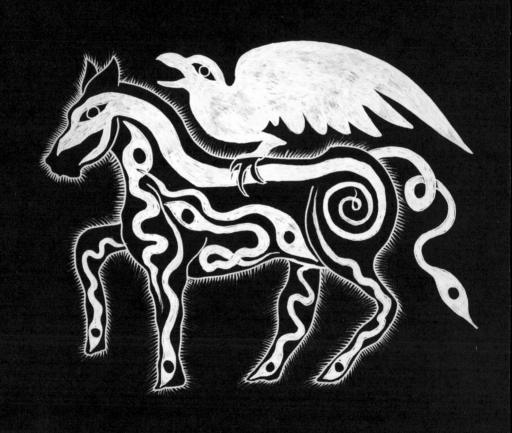

PEGASUS

"He is the spout for the waters on high"
—KABBALAH DENUTADA

It is hard to believe that a pure white heavenly horse could have been born out of gooey Gorgon blood, but such is the story of the birth of Pegasus. Pegasus was brought to me through his mother Medusa as I was researching her for a lecture I was giving at the time. Previously I had not been aware of the grisly circumstances of the origin story of this beast and this discovery led me on the path which uncovered some of the more esoteric meanings behind the beautiful Pegasus.

When investigating the name of Pegasus and its origins, you are most likely to come across information that describes the word as a bubbling spring, or like a fountainhead. Pegasus is something that springs forth, much like he sprang out of the blood of Medusa after Perseus cut off her head with his sword. Some affiliate the name origin with an ancient God of thunder and lightning, making Pegasus a storm God and lord of the skies. Some symbolists equate the spring origin and etymology with a yogic method attributed to Shiva which is a series of techniques to engage the mind into change, or renewal as an ever flowing fountain. This is similar to the alchemical fountain, symbolizing the movement of mercury or mind into new things, making it forever young and new, escaping death in its own rebirth.

"There the river Numitius, in which Aeneas bathing was absolved from his mortality and by command of Venus was transformed into an immortal God...also in a beautifully pictured series there is displayed every antique device of this; Apollo and the muses,

17

and the Fountain struck from Pegasus"
—Mary Anne Atwood, *HERMETIC PHILOSOPHY AND ALCHEMY*

The fountain of blood pouring from Medusa's head brings forth the beautiful pure and free form of Pegasus who is reborn in her death. Medusa is not killed, but rather, transformed into her pure spirit, which is now free from all the thoughts (thus the symbolism of the decapitation, the quieting of the mind) of her hatred. She is set free and renewed.

Pegasus wasn't the only thing born out of Medusa's blood. He also had a brother that spouted forth named Chrysaor. Chrysaor means golden sword, or one who holds a golden sword. The sword affiliated with Chrysaor was a famous golden sword of light known as the Golden Aor, also called the Golden Tusk. Aor was the sword of both Apollo and Odysseus. The tusks reference relates back the etymology of the word Aor itself, which can mean the tusk or horn of an animal that can pierce things. The word Aor, for which Pegasus' brother is named, comes originally from a word used for cattle with long broad horns, also sometimes used for a Rhinoceros horn. Some take this to mean that Chrysaor was the "Golden Horned one" instead of a golden sword, and this would be more along the lines of the interpretations I put forward in this book concerning Baphomet or even akin to that of the Egyptian goddess Hathor. The Unicorn is of course a Horse with a single golden horn, and it seems strange that Pegasus is depicted as a white horse that comes out of the blood with a golden horn; that might make it more like a Pegacorn.

The golden sword arising with Pegasus out of the blood made me think of another story I had read about a white horse and a flaming sword of light held by one covered in blood, the second coming of Christ tale known as the Parousia from the Book of Revelation:

"And I saw heaven opened, and behold a white horse;
and he that sat upon him was called Faithful and True,
and in righteousness he doth judge and make war."
—*REVELATION 19:11*

"Now I saw when the Lamb opened one of the seals;
and I heard one of the four living creatures saying with a
voice like thunder, 'Come and see.' And I looked
and behold, a white horse. And he who sat on it
had a bow; and a crown was given to him, and
he went out conquering and to conquer"
—*REVELATION 6:1-2*

The Parousia depicts a scene in which the messiah enters the end times riding on a white horse descending from heaven wearing a cloak of blood and holding up a flaming sword. This has all the characters of the Medusa story except Medusa: the mount, Pegasus, the sword Chrysaor, and the hero riding it, Perseus, is the Christ figure.

Heroes, or messianic figures dropping out of the sky riding white horses at the apocalypse carrying some magical weapon, are rampant in world mythologies, and these other stories helped provide insight into the true nature of the role that Pegasus plays in these scenarios. These riders and their mounts signify the coming of a new age and the end of the old Tyranny in most of the depictions; an overthrow or ending of a longstanding evil is accomplished through these horse and rider teams. Odin and Sleipnir, the Hindu Kalki and his mount, Perseus and Pegasus, Christ on his white horse, St. George who defeats the Dragon are but a few examples. In Mircea Eliade's work *Shamanism; Archaic Techniques of Ecstasy* he mentions that the Shamans of Mongolia have a White Horse called the khamu-at that comes to take them on their Ecstatic flights into the upper worlds of heaven.

In Islam there is a winged white horse named Al-Buraq who carries Mohammed, the Messiah, to heaven, and is also synonymous with lightning much like Pegasus.

"Then he [Gabriel] brought the Buraq, handsome-faced and bridled, a tall, white beast, bigger than the donkey but smaller than the mule. He could place his hooves at the farthest boundary of his gaze. He had long ears. Whenever he faced a mountain his hind legs would extend, and whenever he went downhill his front legs would extend. He had two wings on his thighs which lent strength to his legs. He bucked when Muhammad came to mount him. The angel Jibril (Gabriel) put his hand on his mane and said: 'Are you not ashamed, O Buraq? By Allah, no-one has ridden you in all creation more dear to Allah than he is.' Hearing this he was so ashamed that he sweated until he became soaked, and he stood still so that the Prophet mounted him."
—Muhammad al-Alawi al-Maliki

The purpose of these white horses throughout the mythologies, including Pegasus, seems to be to carry the prophet, Messiah or hero into the scene of fighting the ultimate evil that is threatening to destroy the world. Pegasus is the flowing water that carries a vessel to its destination, and is often compared, in esoteric circles, to the vehicle or beast of burden that drives the Chariot that carries some god or demigod to its destination.

There is another aspect to the sword, Pegasus' brother, that appeared in much of the Hebraic literature that could be a clue to the deeper meaning of this trilogy of horse, sword and rider. In

the Christian depictions, the sword (sometimes a bow and arrow) is the word of God, and is discussed as existing as early as the Garden of Eden and then being passed along. In Hebrew traditions there is an affiliation that harkens back to the spring idea, or the fountain that also pertains to a sexual reference of the Phallus. Following the root words of phallus we find "Bhel" which coincidentally means shining, white, lightning, burning, and gushing forth, from the root.

Pegasus is the spring and the phallus both together in combination that spring forth in order to conquer; it has the firmness and stability of a steel sword and the flexibility and flow of water. As Carl Jung puts it in his work on describing the Alchemical fountain of Yesod, often depicted as a phallus or penis, and considered the foundation of the world and life itself:

"In the Zohar Yesod; indeed the 'zaddik' or 'just one' as Yesod is also called, is the organ of generation. He is the 'spout of the waters' (effusorium aquarum) or the tube and the waterpipe and the spring of bubbling water... Such comparisons mislead the modern mind into one-sided interpretations, for instance that Yesod is simply penis... but in mysticism... it is always several things at once... Yesod has many meanings which in the manuscript are related to mercurius... the ligament of the soul uniting spirit and body... and is himself the union of these two principles... He is called firm, reliable, constant."

—Carl Jung, *MYSTERIUM CONIUNCTIONIS*

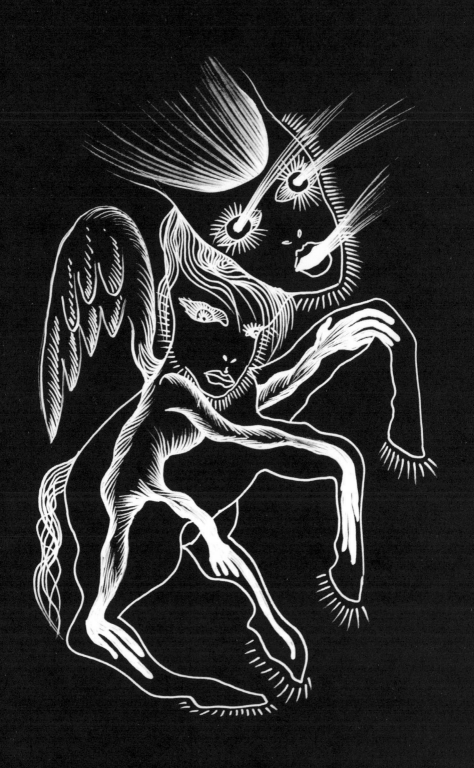

In terms of the Alchemical symbolism of this beast, Pegasus is the steed, weapon and rider all in one creature that emerges from its death victorious in its ability to live to fight another day. As Jesus is raised from the dead in his ascension, and returns in the second coming, so too Pegasus is a glorious representation of the fountain that is life itself, never ending in its many forms that spring forth.

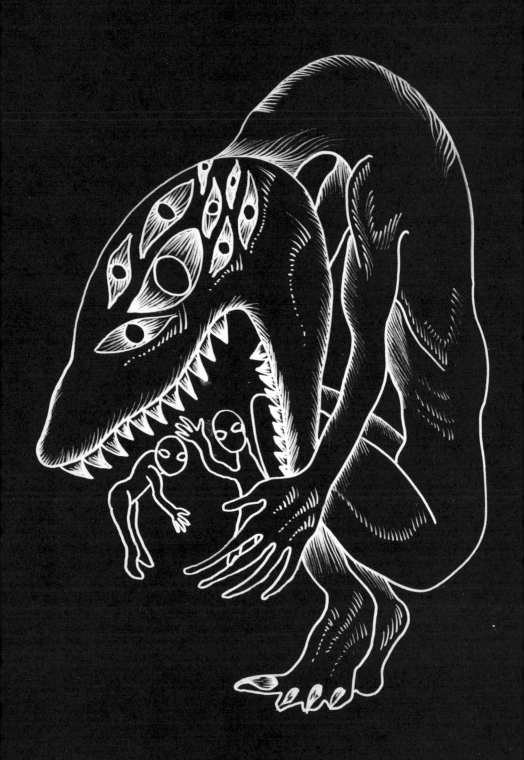

GIANTƧ

"This man was so tall that our heads
scarcely came up to his waist and
his voice was like that of a bull"
—*(FROM THE DIARIES OF MAGELLAN)*
Rupert Gould,
ENIGMAS

The Primordial Forests and Fauna of the primitive Earth were full of Giants. Plants, insects, fish all seemed to have extended boundaries in those times. Perhaps visions of Giants that stretched within human minds were inspired through these bygone eras of bigness. The shrinking down of all the creatures on the Earth from their past enormity is a phenomenon many have studied, and although not everything alive at that time was so large, many living things just grew really big then. According to science, humans were not alive in primordial eras but it is interesting to think about how some things were capable of reaching such great heights of growth and if this could be possible for some human-like species.

Fantastical stories of humongous human beings roaming the Earth are not difficult to come across in every indigenous past, and while looking deeply into the history and creation tales of all peoples, you will find some Giants. In reality, there is and has been a wide variety of sizes human beings come in, from the tiny Pygmies to the towering folks in the Netherlands, but the tales of Giants in days of old reach epic proportions compared to these. Some people are indeed born Giants or born dwarves due to pituitary deformity, but there are also genetic races of people of different sizes. For example, the Pygmies in Africa are the size they are genetically, and are a race, not deformities.

A few years ago, there was discovered a "Hobbit Race" of people in Indonesia, incredibly small, thought to be a deformity but later revealed to be a race of little people, announced on the BBC. These were small hairy people, much like the Celtic "Brownies" described in a lot of the fairy myths. So it stands to reason there could have been some genetic races of Giants. Many feel that the tales of Bigfoot or Yeti could be lost vestiges of these huge hominins. Many folks have been searching for a long time for evidence of Giants with mixed results and claims. In 1935, for example, a paleontologist named Ralph von Koenigswalde found a tooth on the shelf of a Chinese medicine store that he believed belonged to a giant ancient Human race, which was later found to be from an oversized ape (according to the scientific community, though he maintained it was hominin) standing around ten feet high, now known as Gigantopithicus. If Apes could get that tall, maybe humans could too.

The word Giant is of disputed origin. Some affiliate it with the Earth and the name Gaia. In the Greek myths, the Giants are synonymous with the Titans who are born from Gaia; some translate Giant as "children of the Earth," or "born of the Earth." The word Titan means something of enormous size, or great in stature like the sun. According to some, the Giants were born from the Earth in order to defeat the Titans and they were very clearly separated from them in these stories. Others claim they are one and the same, the ancient Titans and the Giants.

The Earth-born Giants are directly related to humans in the Judeo-Christian tradition. None other than the first man himself, Adam Kadmon, is made from the Earth directly (formed from a lump of muddy clay) and is Gigantic. According to the early Jewish literature, Adam was a Giant as large as the planet. In the legends they weren't shy about mentioning how big he was. In the descriptions of the first man from the ancient texts he was huge and full of light, kind of like the sun. Much mention is made regarding his "stature."

The allegory of Adam in the early Jewish materials would seem to imply the father of humanity was a literal Giant. Another idea could be that Adam was not a gigantic man, but a gigantic creature, namely all creatures all together, the Earth. Plutarch also called the primordial man a "macroanthropos" and the Upanishads in the Indian traditions state that the first man, known as "Purusha," was a cosmic Giant as well. Perhaps these Primordial human tales were trying to present the symbolism that we are all smaller parts of a gigantic living being that is our relative, the Earth.

In Alchemical and developmental symbolism, the Giants are said to be the Earth-born things that sleep beneath the surface of our consciousness in our lower mind. They are the primordial complexes and forces of nature that live within us all, just out of the reach of our awareness until they take us over and consume us in our entirety.

In most cultures, the Giants tend to be presented as depraved cannibals who caused a lot of trouble for the regular-sized folks and ate up all their food. The word Ogre means specifically a man-eating Giant, and also monster or Demon. There is a very Evil connotation with many Giants, and they have, in some circles, a demonic and terrible reputation. In Norse mythology the word for Giant comes from the Rune called Thurisaz or "Thorn," which derives from "Thurs" or "purs" and means simultaneously giant, monster and demon.

According to Judeo-Christian, Celtic and Vedic sources, Giants are the descendants of fallen angels traditionally identified as demons. Usually, the Giants are considered evil specifically because they are cannibals. The Titans are included in this grisly description, for Saturn certainly ate his own Children over and over again. The Giants were known for having huge appetites and would create violence and chaos everywhere they went. Greedy thieves, they took what they pleased. Almost every child is familiar with the cannibalistic Giant in "Jack and the Beanstalk" who just wanted to eat Jack. The phrase "Fe fi fo fum"

from the famous fairy tale can be traced back to Gaelic Celtic origins, and was translated as "behold! Something good to eat." In the Celtic fairy religion, the source of Giants is also from fallen angels, though there are some descriptions from Scandinavia that say the Giants are the children of Adam Kadmon himself. The Celtic stories are also closely mirrored in the Vedas, where the same tale is told. The angels in the Vedas, known as the Rishis, come down to Earth and intermingle with humans, making monstrous Giant progeny that fill the Earth. In almost all these versions, the Giants eat and pillage everything, including humans and make a big mess.

"This is supported by the Greek text of Watchers
from Panopolitanus. According to this manuscript,
I En. 7:2–5 reads: The women became pregnant and
gave birth to great giants, 3,000 cubits tall.
They ate the labors of men. As they were unable
to supply them, the giants grew bold against them
and devoured the men. They began to sin against
birds, animals, reptiles and fish, and to eat the
flesh of each other. And they drank the blood."
—Matthew Goff, *MONSTROUS APPETITES:
GIANTS, CANNIBALISM, AND INSATIABLE EATING
IN ENOCHIC LITERATURE*

The cannibalistic Giants of the Bible are called the Nephilim. There were different genetic races of Nephilim, such as the Zamzummim, Gibborim and Rephaim, even having their own recorded languages. The Alchemist Paracelsus spoke of the language of the Gibborim, an angelic language, called Gibberish. In the Bible in Genesis 6:1–6:4 the creation of the Nephilim is described, and is expounded upon at great length in the apocryphal book of Enoch. The book of Enoch is controversial but there are many references to it in other Jewish historical texts. According to

these stories, the fallen angels called the Grigori, or the watchers, were a group of angels assigned to watch Humans, like guardian angels. They became so enamored with the Humans that they had sexual relations with them and thus came the birth of the biblical Giants.

The Bible gets specific in naming the bloodlines of these Nephilim and they keep track of all of them. Like the giant named Og, for example. In old stories, Og survived the flood sent by God by stowing away on Noah's ark. It was said that the reason God sent the flood in the first place was because of how horrible the Nephilim were and the idea was to erase them from the face of the Earth by drowning all of them. Noah was one of Enoch's descendants and was chosen to deal with the chaos left on Earth caused by these unruly giants. It was written that the hearts of the Nephilim had all been corrupted and they could no longer love or care for things so they were a waste of destructive energy. Og managed to stow away because he flirted with a wife of one of Noah's sons, and then ran off with her to make another bloodline, from which eventually sprang Goliath who would later be defeated by David according to the legend.

Mirroring the stories and legends of the Nephilim very closely are the tales from India regarding the Giants known as the Asuras. They are described as having three heads with three faces each and four to six arms. The Asuras are also known as Demons and cannibals, but instead of these giants being vanquished by a flood, they are defeated by a Goddess. The Goddess in her three forms, Kali, Chandi, and Durga comes in to save the day and defeat all the man-devouring Giants in a battle that is extensively detailed in the history and culture of India. Kali defeating the Giants is one of the earliest hero stories and the undefeated champion is a lady.

The Asuras are translated as the "Titans" and the "Demons," and there are also connections from the Indian versions to the Nordic sources; in the Norse sagas one of the words used for Giants is Aesir, thought

to be etymologically related to Asura. In the North it meant "Lord" or "powerful" or large. The most prevalent tale in Vedic myth tells of the great battle between the Asuras and Kali. The Flood that wipes out the Giants in the Indian version of the story is not a deluge of rain as in the Judeo-Christian take, but is a sea of blood that spills forth from the king of Giants and all his offspring when the Goddess kills and eats them all in a violent rage. This flood of blood is the cleansing that takes place and all the Giant demons are eaten just as they had done to so many others.

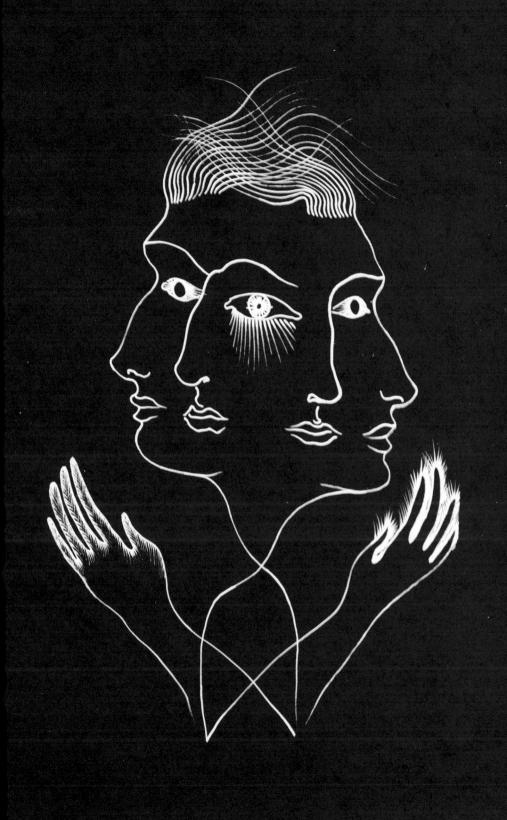

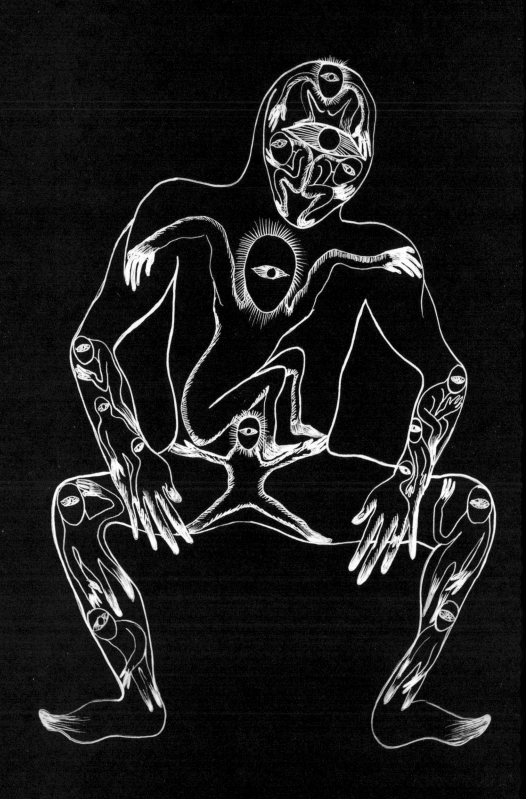

CYCLOPS

"The cosmic Hierogamy, the marriage between heaven and earth, is a cosmogonic myth of widest distribution...Ouranos, Heaven unites with Gaia, the earth and the divine pair engender the gods, the Cyclops and other monstrous beings."

—Mircea Eliade,
MYTH DREAMS AND MYSTERIES

There was a famous type of cannibalistic Giant known as the Cyclops. In Irish folktales, the Cyclops was the King of all the other Giants and their offspring, portrayed in a one-eyed god named "Balor" who ruled all of the Giant demons known as the "Fomorians." Although the Cyclopses were shown to be just as unruly and people-eating as the Nephilim in many respects, they seemed to have a particular trade or skill regarding their abilities. The Cyclopses were known as builders and creators of things. Most of the regular Giants just went around wrecking everything, while the Cyclopses were more proactive.

In Hesiod's description of the Cyclopses, they were emotional and guttural creatures who were masters at the forge. The Cyclopses came to be identified with skilled architects, weapon makers and powerful Blacksmiths. According to esoteric sources, many imposing ancient structures are said to have been built by Cyclopses. There are ancient folk stories claiming Cyclopses forged Stonehenge which may sound fantastical, but such tales can also be found regarding the origins of the Pyramids and enough other impressive historical

structures to warrant further thought. Is the symbol of the single eye above the pyramid on the dollar bill really just the signature of its creators, the Cyclopses? There are some who express the Cyclopses were the original masons and they are tied into the claims of the Freemasons of the dawn of architecture. In her work *The Secret Doctrine* Madame Blavatsky speaks at length on this and notes that the Cyclopses specifically were the ones responsible for buildings made of "hewn stone." The ability to build with stone is credited to these mythical huge one-eyed creatures. The wording "Hewn Stone" is echoed in Bible literature and there were a lot of very strict rules and regulations for creating things out of stone, whether these were statues, buildings or things made from molten metal. Humans were not permitted by many creator Gods to build things out of stone; that was a job for the Giants. You also were not supposed to remove the stones from their resting places, so cutting away a bunch of stone and metal and taking it somewhere else was considered bad form. The laws of most of the ancients encouraged humans to only make things out of rock where they lay, and not to transport them. That rule was for buildings as well; they needed to be made in the place the stone was in order to be acceptable. The Cyclopses, being mountain dwellers who lived deep within the Earth, were able to follow this rule and build things properly out of Hewn Stone.

Because there are quite a few impressive almost impossible ancient structures made of "hewn stone" that were also somehow tied in to the stars, planets and seasons, the Cyclopses also gained an affiliation with stargazers and early astronomy. The fact that there were specific placements of the huge pyramids and Stonehenge in alignment with astronomical events have led some to form the opinion the single eye may symbolize that they gazed through telescopes at the heavens, or perhaps the monocular view represented the Pole star as a single focal point.

In the Greek myths, the Cyclopses were responsible for making most of the magical weapons used by the gods.

Poseidon's trident, Artemis' bow and arrow, and Zeus' lightning bolts all were crafted by their Giant hands. These Cyclopses were said by the Greeks to all live in a Volcano deep in the Earth with Vulcan who was a blacksmith and master metal worker. The local legends in regions of Greece placed the Cyclopses' residence in a Volcano near Sicily. Since the most well-known weapon created by the Cyclopses were the Lightning bolts of Zeus, I can't help but notice that Volcanos also perform this miracle. When a Volcano is erupting it literally makes lightning. There is a close affinity between the Volcano and the Cyclops in many of the tales. The famous Cyclops Polyphemus in the story of the Odyssey, for example, is living in a cave on a Volcano that erupts during the story.

The correspondences of the blacksmith and metallurgist with the Cyclops becomes illuminating when we consider an historical habit of Blacksmiths to use an eyepatch to cover one of their eyes while working the forge in order to protect their eyes from flying sparks. Back in the day before safety goggles or face masks, it would make sense that they would need some kind of ocular protection from the shards of metal that would fly loose after the poundings of their hammers. In Egypt too there are tales of these giant assistants to the master blacksmith; they are called the Khnemmu who help Ptah, the original metal worker and alchemist. They turn the wheel of the forge in order to smelt the metals extracted from the Earth. This stone was also known as a "grindstone." This wheel can be seen to correlate to the literal meaning of the word "Cyclops," which can be translated as "turners of the wheel" indicating a Cyclops is one who cycles around a circle or wheel. Blacksmiths have long been revered as Gods and magical beings, and the ability to smelt metals and transform things using fire is often marked as a distinguisher of humanity from beasts. In his work *The Forge and the Crucible*, Mircea Eliade does an excellent job of detailing the magical and psycho-spiritual nature of the Blacksmith and weapon creators, and calls them the original Shamans who exert power over Nature and are "masters of fire."

It deserves mention that a single eye has long been used to represent God itself through many cultures. The ultimate religious symbol, occult or otherwise, is the all-seeing eye of providence. When not found on the face of a Cyclops, a single eye floating in space became known as the presence of God. This eye in the sky is shown all over the place. It could perhaps be taken to mean then that God was either a literal Cyclops, or that somehow coming into a singularity of focus confers God-like qualities. A perfect example of this can be seen in Egypt where the symbol for the supreme and ultimate God was an eye floating in the sky known as the eye of Ra.

Another version of God who was a Cyclops can be seen in the Norse sagas of Odin. Odin is often compared to Zeus, as he is the head father God of all the other Gods and has a relationship with Thunder and Lightning much like the Volcanic Cyclopses. Not only did Odin have one eye, but he also carried around a blacksmith's hammer. Some scholars argue that the Hammer was unique to the God Thor, thought to be Odin's son, but other research investigators claim that Thor came later, replacing Odin, and that Odin was the original version of this God. Odin sacrifices his Eye on purpose in order to gain wisdom, making it a voluntary act, not an accident. He sat at the Ancient well and wanted a drink to gain knowledge, but the well said it would cost him his eye, which he willingly tore out and threw into the water. Somehow having only one eye gave Odin insight and foresight after drinking from the magical well. The acquiring of wisdom by making the eye single here echoes some other ideas that the Cyclops represents enlightenment through the engagement of the pineal gland, known as the third eye.

Some interpretations of the symbolism of the Cyclops say it is not a single eye, but the presence of a third eye that is trying to be conveyed. For many in India and Eastern traditions, the Cyclops meant something more along the lines that your pineal gland was operating at full capacity.

"The Greek mystics also carried a symbolic staff, the upper end being in the form of a pine cone, which was called the thyrsus of Bacchus. In the human brain, there is a tiny gland called the pineal body which is the sacred eye of the ancients and corresponds to the third eye of the Cyclops. Little is known concerning the function of the pineal body, which Descartes suggested (more wisely than he knew) might be the abode of the spirit of man. As its name signifies, the pineal gland is the sacred pine cone in man—the eye single, which cannot be opened until Chiram (the Spirit Fire) is raised through the sacred seals which are called the Seven Churches in Asia."

—Manly P. Hall, *THE LOST KEYS OF FREEMASONRY*

Lastly, there are some very intriguing references to species of Cyclopses that lived in particular areas. These regions were all near mountains that also contained Volcanoes. In the work of Herodotus is what he calls the "Arimaspi." The Aramaspi were one-eyed inhabitants of the mountains north of Scythia in the ranges of the mysterious Ural region. In the description by Herodotus, the Cyclopses that lived here were giants and nomadic and would travel the plains. The story of some mysterious one-eyed race living in the parameters of this spot is corroborated in the folklore of the Mongols, the Ukraine, the Chinese and India as elucidated by Jonathan Radcliffe in his work *Arimaspians and Cyclopes: The Mythos of the One-eyed Man in Greek and Inner Asian Thought.*

In the stories of these Cyclopean people, the Aramaspi, they have but one obsession and that is stealing gold from the Griffins to smelt in their blacksmith pursuits. Tales of their struggles with the gold-guarding Griffins in the Hyperborean lands near the mountain caves are related in a work by Aristeas of Proconnesus.

To derive further information on these metaphoric, symbolic but also perhaps historically existent Gigantic, intelligent beasts with unsymmetrical eyes that reveal celestial visionary capabilities, we can look to the Griffins who play the role of the antagonist for the Cyclopean beings.

GRIFFINS

"the sharp-toothed unbarking hounds of
Zeus, the Gryphons—Beware them and
also the one-eyed cavalry horde of the
Arimaspians who dwell by the font of
Plouton's stream which flows with gold,
do not approach them."

—Aesch PV803-6

Griffins are beasts found shielding precious things. They are Gate-keepers and Guardians. The Griffin guards not only with the ferocity of its animal nature, but also with intellectual and psychological tests. It is a form of trickster, and keeper of riddles to guard sacred knowledge. Many scholars feel the Sphinx, who would challenge people with riddles in a contest of wits, is also a Griffin.

Popular stories of these creatures come from Herodotus and Pliny the Elder. They inhabited the same areas as the Cyclopses, in the northern regions of the Scythians at the foot of the Altai mountains. Here they keep the gold protected from the Cyclopses known as the Arimaspians. There was an historian, Adrienne Mayor, who thought this could be from beaked Dinosaur fossils found near gold mines. Perhaps the ancient humans found these bones and imagined the beast in their best approximation. The Scythians certainly believed in their existence: ancient mummified remains of these people have found tattoos of unmistakable Griffins on their skin preserved by the ice and cold, and the oldest accounts of the existence of Griffins come to us from encounters with the Scythian tribes.

Traditionally, the Griffin is known as a hybrid creature, half Eagle and half Lion. A combination of the king predators of the skies and land. Various combinations of the attributes of these two creatures are shown in several forms in multiple cultures. Sphinxes and Griffins were depicted in Babylon, Sumeria, all over Persia and Asia perched at the entryways.

The name Griffin means curved or hooked like a talon, claw or beak. But there is also a hidden older meaning in its prefix, "Gryphe," which means enigma. The word Griffin was affiliated with a conundrum that you had to traverse in order to get to whatever it was the Griffin was guarding.

"The utterances of the oracles and the Grecian Sphinx of Sophocles were thus couched in enigmas. Aeschylus and Pindar also refer to them. According to the earliest grammarians, the enigma was one of five (subsequently seven) types of allegory and was synonymous with gryphe which according to Estienne, quoting Gellius, came from the Greek Gryphos, a net, since the underlying meaning or what is signified is caught in a net."
—*THE LIBRARY OF RENAISSANCE SYMBOLISM, THE SYMBOLIC LITERATURE OF THE RENAISSANCE*

If one were to study the purpose of these conundrums in Grecian times, the Griffin and the Sphinx really represented a boundary into another level of consciousness that a spiritual seeker had to cross and that the treasure of gold they guarded was access to God or Spirit.

When people imagine a Sphinx, the king of everyone's mind is the one in Egypt. Sphinxes share the main attributes of Griffins in that they are usually shown with Lion bodies and Eagle wings, only they have

a variety of different types of heads. There are several scholars who
suppose the Sphinx of Giza had wings at one point. This is evidenced
by the many other Sphinxes throughout Egypt that have wings. There
are hundreds of them. Some Egyptologists theorize that the Sphinx of
Giza had a different head that was later replaced. Throughout many
countries, China, Persia, all over the Middle East there are always pairs
of Griffins, Sphinxes or Foo dogs that guard the entrance to either a
temple or some other venerated location. The road to the temple of
Luxor was lined with many Sphinxes, guarding the pharaoh Nectane-
bo, whose kingdom was around 380-362 B.C. They were also shown
in front of Chariots, pulling the Gods as their beasts of burden. This
is most popularly depicted in "The Chariot" card of the Tarot where
there are two Sphinxes prominently displayed at either side, pulling the
Chariot forward. One Sphinx is black and the other white and together
they make up an inseparable pair.

The name "Sphinx" isn't Egyptian at all; it is actually Greek in
origin and means "to strangle." Some interpret this name coming from
the tales of the Griffins and Sphinxes attacking their victims who did
not get the key correct; in their guardian duties they would grab the
victim by the throat and strangle them. Sphinxes and Griffins were man-
eaters and considered dangerous. Many met their end through giving
the incorrect answer to the riddle of the Sphinx.

The riddle portrayed by the Greeks that the famous Sphinx in the story
of Oedipus used was as follows:

"What is the creature that walks on four legs in the
morning, two legs at noon and three in the evening?"

The answer Oedipus replies to this mystery is "Man" (but also the
Sun) and being the correct response, the Sphinx dies. I personal-
ly feel there is also a subverted meaning in this tale, however, that
many disregard. The story of Oedipus is about a man who walks

with a cane because he has a limp due to a bad foot. When Oedipus approaches the Sphinx to answer its riddle, he is using a cane and literally has three legs just as proposed in the creature. The reason Oedipus was the one to solve the riddle was because he recognized it was himself, not just "man" but he, the one who stood before the Sphinx with three legs. It was his knowledge of himself that gave him the answer.

Psychologists had a different take on the symbolism of the Sphinx and Oedipus story and related it more to the feminine and masculine energies and sexuality.

"The Sphinx in its traditional form, is a half human, half animal creature...This manner of representation is very familiar to the analyst, through the dreams and phantasies of neurotics (and of normal men). The (sexual) impulse is readily represented as an animal, as a bull, horse, dog etc...Dreams swarm with such theriomorphic representations of the libido. Mixed beings, such as are in this dream, are not rare... The libido which was represented theriomorphically is the animal sexuality which is in a repressed state... From these roots, as we pointed out earlier, might probably arise the theriomorphic attributes of the divinity. In as far as the repressed libido manifests itself under certain conditions as anxiety these animals are generally of a horrible nature. In consciousness we are attached by all sacred bonds to the mother; in the dream she pursues us as a terrible animal.
—Carl Jung, *PSYCHOLOGY OF THE UNCONSCIOUS*

The Egyptian word for Sphinx is slightly different in its meaning and purpose though still consistent with the Boundary Guardian and one who watches over something.

One name for the Sphinx was "Heru-em-Akhet" that translated as Heru of the Horizon. Heru was a Demigod type of figure who became God-like and had an affiliation with the Dawn and sunrise. The Sphinx of Giza is placed directly watching the Sunrise in the direction of the East, so this name was given to it for its eyes were forever facing the rising sun.

The other Egyptian name of the Sphinx was Shesep-Ankh and that meant "One who carries his heart in his eyes." This was also translated as "Living eyes." Some scholars even take it to mean "seeing the life of something in its eyes" and it morphed into being known under the title "Living Statue" or "Living Creature."

This name, Shesep-Ankh, is more like a sentinel or watcher. One whose eyes never close, and this too is the meaning of guard, or one who watches. The Coptics, who were the indigenous Egyptians according to many, had their name for the Sphinxes and Griffins which was "Bel-Hit" meaning one who carries their heart (or intelligence) in their eyes, literally translated as "watcher" so it was similar to Shesep-Ankh.

The idea of the Sphinx as a "Living Creature" might not make much sense, but it can be pieced together into a much larger puzzle involving the Judeo-Christian Bible, and very well known figures from these myths and stories commonly known as the Cherubim.

CHERUBIM

"He rode upon a Cherub and flew;
And he sped upon the wings of the wind"
—Psalms 18:10

Although the Angels might not be the first things you think of when you think of a beast, it might be truer than you think. In modern times Angels are pleasant-looking people, beautiful women, chubby babies or ripped warrior men holding swords. Those aren't the angels I will be describing in this volume. Here we shall examine the Beastly Terrifying Angels who appear in the form of fantastical creatures known as the Cherubim.

It is important to remember there are many forms the Angels are said to take, so it would be silly to try and trap them into some kind of single identity. The fact that angels took on some terrifying appearance is evidenced in the words Angels first speak to humans, whenever they encounter them: "Do not be afraid." This sentence alone tends to call into question the serenity of their appearance. Some of their shapes are even geometrical, leaving all biostructure behind to cling instead to lines and curves, such as the Ophanim who appear in the form of five rings, much like the insignia of the Olympics. There are several kinds of beastly type of Angels, such as fiery serpents, but there is one specific kind of angel described as having the same façade as some of the mythological beasts, the Cherubim.

The Cherubim are described as having four different faces of four different creatures that are all contained in the same creature. Much like the hybrids such as Sphinx and Griffin, the Cherubs are an amalgam of animals. The faces they express are those of the Ox, the Lion, the Eagle, and a Human. The faces of the Cherubim are typically

affiliated with the four directions, North, South, East, and West. In the largest description of the Cherubim, the vision of Ezekiel, these four faces in the four directions enable the Cherubim to move in a way that other things can't. They are described as moving simultaneously in all directions at once, and usually have a whirlwind, storm or tornado surrounding them.

The oldest renditions of these creatures are found in the ancient Hek-halot literature of the Kabbalists. This writing tells of a magical chariot that carries God. There are several layers in this vehicle. At the bottom there are the Ophanim which are the wheels. Next come the Cheru-bim, the beasts who pull and move the chariot. Then the Chariot itself, followed by the throne set upon it. On the throne itself is found God whose face cannot be seen. The Cherubim are the beasts of burden who maneuver and protect the contents of the chariot and what sits upon its seat. This scene is depicted in several of the cards in the Tarot deck. The card the Chariot shows the Cherubim as Sphinxes at the base. The four creatures are shown on the four corners of the card the World, and can also be seen holding down the corners on the Wheel of Fortune card.

In Jewish traditions, the Cherubim are also known as the Hayyot/ Chayyot, and sometimes called Tetramorphs by the Christians. In Christianity, the Cherubim came to be affiliated with the four evange-lists, and they can be seen in Christian churches of all kinds, although most predominantly the evangelical. The Evangelists Matthew, Mark, Luke, and John were seen as the aspects of the Tetramorph. The most famous depictions of these can be found in the Book of Kells, much later than the Hekhalot literature of course, so it could be said that the Christians usurped these creatures for their own symbolic purposes.

The name Hayyot contains many secrets. In Hebrew this name is translated as "living creature." This living creature title was one the Egyptians had also given to the Sphinx, forging a link between these

two. The word Hayyot has a relationship to life itself, as the word Chai, meaning life, is at its root. Something about the Hayyot has to do with the secret of life. Deeply mysterious is another application of the name Hayya, Adam's mate Eve, whose name in Hebrew is Hayya; some Rabbis think this is a play on the Woman's ability to create life.

This life connection becomes evident when Adam is given life by the breath of the Holy Spirit. It was said that Adam first had what was called a "Nephesh," a type of soul that all animals had, but that then, in addition to this, the Holy Spirit breathed into him the Hayya. Some Christians misinterpreted this ancient Hebrew telling to mean that Adam had an extra soul, or "Living soul," that gave him dominion over the animals, when in fact, all things that are alive also had the Hayya, so this actually meant that Man and beast were equal. There were four types of souls in Judaism, and the Hayya was nearly at the top, second only to the Yechida. Hayya in Hebrew can mean community, or a bunch of things all together as one thing, like the Hayyot are four things that are one thing.

The Hayyot were given some pretty important guardian jobs. They were the Guards at the four gates of the Garden of Eden. After the Fall of Adam and Eve, the Hayyot were set at the four sides of the garden to keep out anyone who didn't belong there and to guard the tree of life and the fiery sword. They were also in charge of guarding the Ark of the covenant.

In the detailed descriptions remaining of the mysterious Ark, the Hayyot are right on top of it. There are two of them, sitting facing each other, directly across in a mirror image of the other.

> "and thou shalt make two cherubims of gold, of beaten
> work shalt thou make them, in the two ends of the mercy
> seat. And make one cherub on the one end and one

cherub on the other end: even of the mercy seat shall ye make the cherubims on the two ends thereof. And the cherubim shall stretch forth their wings on high, covering the mercy seat with their wings, and their faces shall look to one another, toward the mercy seat shall the faces of the cherubim be. And thou shalt put the mercy seat above upon the ark; and in the ark thou shalt put the testimony that I shall give to thee."

—*EXODUS 25*

This magical recipe of placing two or more of these creatures in a place welcoming in divinity to some kind of throne that is between them is mentioned in Egyptian literature as well, and is the reason for the Sphinxes guarding the temples and pyramids in pairs. Jewish legends also include their presence as necessary for spirit to enter in this equation:

"Their purpose seems to have been protective, to prevent, perhaps only symbolically, unauthorized individuals from entering space where they were not allowed. In the Exodus tabernacle the creatures seem to function as protectors of Yahweh's presence. They are the last barrier between any possible human entrant and the divine presence. it is not only out in front of them but 'between' them. Says Yahweh, 'I will meet with you and give you all my commands.' It is therefore also significant that winged composite creatures are found flanking the thrones of kings in the ancient world."

—*NIV, CULTURAL BACKGROUNDS STUDY BIBLE: BRINGING TO LIFE THE ANCIENT WORLD OF SCRIPTURE*

Based on some of these powerful descriptions of the Cherubim, they seem to have a soul that Humans also have, be alive, and are able to guard a divine presence. Some have theorized that the divinity in the center could be a person flanked by two spirit guardians on either side of them.

The Cherubim could be our guardian angels.

Many indigenous cultures speak of animal guardian spirits that are with us throughout our lives. It is quite possible that the God riding the Chariot is us and that the guardian spirits surrounding us are only those creatures talked about in ancient cultures that are our familiars, or "Close kindred" as Barbara Walker calls the Cherubim. The Nez Perce tribe call the Guardian spirit the Weyekin, or Wyakin. The Weyekin were a spirit that could be obtained through a vision quest, after which they would guard the person and offer them spiritual advice.

The most famous name of the personal guardian spirits, though, is ironic as we make our way into the next beast from these Angelic beings: they are none other than the Demons.

DEMONS

"For certain minutes at the least
that crafty demon and that loud beast
that plague me day and night
ran out of my sight;
Though I had long perned by the Gyre,
Bewteen my hatred and desire
I saw my freedom won
And all laugh in the sun"
—William Butler Yeats

The Demon, now a vicious evil Beast, was first known as a Daimon, or genius, and was more like a guardian angel. The Daimon was the guiding spirit of each individual and was given unto them at birth. The two could never be lost or separated; only we come in and out of communication with our guidance systems. This guiding genius was seen as a type of animal or creature in many ancient cultures and perhaps this was why it came to be that it was demoted to a less than godly status by modern Christians. The Witch's familiar and the indigenous Totemic spirit took on a dastardly role through the Church's lens and so were forbidden and downtrodden.

The word Demon is Greek and comes from Daimon, which meant a portion or section of the divine. It is related to divination and the drawing of lots, or dividing things into lots that would then become our fortunes and fates. The Daimon had a direct role to play in the discovery of our destinies and it was our personal tour guide through our lives to make sense of this crazy world, also called the Conscience. The

Demon was the communicator between God and Humans, a go-between that could assist us with the deepest mysteries.

"All that is Daemonic lies between the mortal and the immortal. Its functions are to interpret to men communications from Gods. Commandments and favours from the Gods in return for Men's attentions and to convey prayers and offerings from Men to Gods. Being thus between men and gods, the Daemon fills up the gap and so acts as a link joining up the whole. Through it as intermediary pass all forms of divination."
—Plato, *SYMPOSIUM*

Even though many Greek Scholars affiliated its presence with divinity and intelligence above what a human could achieve on its own, the Christian Greeks came to see this as a malignant force that was to be avoided communicating with at all costs. The Daimon turned from guidance system into unclean spirit and was discarded. Even the most advanced minds such as Socrates swore by their useful and angelic presence but that was not enough to convince the hard-minded Christians that the Daimon was anything more than Satanic and evil. Today anyone caught hearing a voice that is not their own is far from being considered touched by God and is instead thought to be touched in the head.

Originally these guiding entities were worshipped in Pagan cultures, and Idols and statues were made of them in both indigenous lands and more developed ancient civilizations. After the advent of the Christian church the statues and the worship of them was strictly forbidden as an Idolatrous Pagan practice, and anyone caught paying homage to a Daimon or performing divination was killed for Blasphemy and making Graven images.

In Jewish folklore, the name for the Demon is Shedim. Shedim in Hebrew was affiliated with Storm, but also an ox-like creature. Much like the Cherubim mentioned above had a tornado or whirlwind around them and the face of an Ox, we see some obvious correspondence with these two entities. The Shedim were thought to be part human, but unfinished, made by God from the same clay as Adam, but not completed.

There were specific kinds of Shedim that were in their animal form and these were called "Se'irim" which meant "hairy beings." The Shedim were thought to not only be spiritual creatures, but they could also live inside of, or take residence within a living creature, like an animal. Certain animals were thought to carry Shedim more than other ones:

"The first or lowest mode of Animal Worship is that form of deference or veneration which arises from the persuasion that certain animals are invested with demoniacal powers. Such a notion is universal among savage and semicivilized peoples, and still survives to a great extent among members of the most cultivated of modern communities. The whole ancient Semitic population of western Asia was infected with this superstition, which manifested itself in many different ways. In Babylonia it was especially rife. Hundreds of spirits are referred to in the religious cuneiform texts. Every condition and activity of human life was subject to their influence; and their forms and characteristics were as various as their occupations."
—JEWISH ENCYCLOPEDIA

Probably the most famous example of this in Judaism was the worship of the Golden Calf that Moses witnessed as he came down the mountain carrying the word of God. Most people are not aware that a very well-known Jewish Patriarch, King Solomon, used communication with Demons extensively and was an Idolater. King Solomon spoke with Demons at length and even used them to build the first Temple of the Jewish Faith, the Tabernacle. According to the legends he had a ring that enabled him to control the Demons, making him the original lord of the rings. This ring was eventually taken from him by the King of Demons, and Solomon fell into a life of vagrancy and despair until he regained the ring by accidentally catching a fish that had swallowed it and began working with the Demons again. It was rumored that by the end of his life the Demons had such a tight hold of him that he had to sneak away to die so that they would not interfere with the passing of his soul. It was from his workings with the Demons that we get Solomonic Magic, used so extensively by groups like the Golden Dawn based on the texts known as the "Clavicules de Salomon":

"It is not unlikely that a sovereign who had
sacrificed to Moloch, Chemosh and Ashtoreth
should try to evoke demons or write regarding
the method of enforcing their appearance.
Christian authors have affirmed that he did so...
Leonitus of Constantinople...spoke of
Solomon's power over Demons: Had not
Solomon dominon over Demons?"
—Grillot De Givry, *WITCHCRAFT MAGIC & ALCHEMY*

The main offerings made to these Demonically charged idols by their worshippers was blood, either that of a human or animal, and the tradition of offering up the blood of something to these types of deities extends back into prehistory covering the circumference of the globe.

Some of these Daimonic blood drinkers of fame include Baal and Apis, two legendary Bull blood sacrifice cults. As mentioned in the chapter on Vampires, eating blood was taboo in most places because the blood was to be the food of the Gods, not the food of humans. For this reason, the blood that was taken from the beasts that we humans ate was always to be offered up on high.

The Egyptian version of the Daimon is called the Ba. The Ba was shown with a human head and Eagle's body, and represented the driving characteristics, intelligence and nature of its Human counterpart. It was believed that after the person died, this aspect of the soul would leave to begin its journey to the afterlife. The Ba was affiliated with the body and corporeal aspects of the human and could influence and drive its fleshy palace to make decisions and search for its destiny.

The Chinese had their concept of this counterpart as well: it was called the Po, though some argue this was different than the guardian spirit, stating these were something called the Hu fu Shen. The Chinese Taoists and nature worshippers had a complex understanding of the Human soul and divided it into two main parts, the Hun and the Po. Under these two were other denominations, but these formed the main pair. The Po was the animal soul of the flesh and the body and the Hun was the spirit, or spark of heaven that lived housed within the Po. The Chinese saw the Po as all of our animal instincts and compulsions and felt it had to be domesticated in order for the Hun to have equal say. When the person died it was thought that the Po returned to the earth as is the way of all flesh and the Hun returned to Heaven. The Po was affiliated with Metal and was thought to be sharp like a sword, as the Daimon, a decider, or divider who made choices and discerned between right and wrong. If your Po was undeveloped, it might make poor choices, so much of the Taoist work focused on the development of this Animal soul to ensure a clear channel for the intellect to make the right moral choices.

"In the...bodily existence of the individual...are...
two... polarities, a *p'o* soul (or anima) and a *hun* soul
(animus).

All during the life of the individual these two
are in conflict, each striving for mastery. At death
they separate and go different ways. The anima sinks
to earth as *kuei*, a ghost-being. The animus rises and
becomes *shen*, a spirit or god."
—Richard Wilhelm and C.G. Jung, *THE SECRET OF
THE GOLDEN FLOWER*

All of these different versions of worshiping and acknowledging our
Animal Spirits seem to be representing the same concept, that of
coming into a relationship and dialogue with them. For many
of the indigenous this was done through the vision quest, but
other ancient cultures developed these into more complex systems
of conversations through divination and direct relation through a
representation of the spirit such as a statue or image of the beast.
It seemed everything went wrong after some of these techniques
were perfected and yielded tangible results, causing other groups
to admonish having relations with our animal natures, choosing
instead to abandon the practices of worshipping the stone façades of
our guidance givers and no longer heeding the voices in our heads.
Rather than viewing our Demons and inner animals as evil influ-
ences to be fought against and reviled, we could perhaps take a cue
from Madame Blavatsky. She aptly points out in her work *The Secret
Doctrine* that the old adage "Demon Est Deus Inversus" can only be
true in belief systems that have not progressed out of dualistic thinking.
In a non-dual universe, all adversaries are only part of God, and not a
real enemy.

"If God is Absolute, Infinite and the universal root of all and everything in Nature and its universe, whence comes Evil or D'Evil if not from the same Golden womb of the absolute?"
—Madame H.P. Blavatsky

GOLEM

"Why, if all the creatures in the world gathered together to make a single gnat and put a soul into it they would not succeed! No more than man can make a gnat can demons, according to another tradition, make anything smaller than a grain of barley. But those who favored the Thaumaturgic interpretation of the Book of Yetsirah, and believed that a man or Golem could be created with its help."

—Gershom Scholem

As I sat down to create the chapter on the Golem, my roommate had returned from work and had received a package in the mail. She opened it to reveal ceramic pottery of bowls, mugs and cups that were made from clay. They were made by her Mother who lived in the Appalachian mountains and she related to me that she used to go with her mother down to the nearby river to retrieve the clay from its muddy banks, and all the vessels were fashioned from it. It seemed an appropriate start to my adventure into the mud-made forms we humans create.

The Golem is a creature created by humans out of the Earth. A living statue like a voodoo doll come to life. This might sound absurd and becomes even weirder when reading ancient tales of the creation of humans by the Gods that describe us emerging to life in

the same manner: being molded out of clay. Primordial gigantic humans come straight from the mud of the Earth in the early sagas, and the Golems are only an attempt to mimic this birth from the Earth.

In their etymology at least, humans are deeply connected to the Earth as our name "human" shares its origins with the dark and fertile soil. The root word "dhghem" means earth; homunculus; human; humane; humble; humiliate; humility; humus, humus being another word for earth. Somehow the Golem is tied into the creation of humans, so to understand the Golem, we have to understand Human creation stories. We are all familiar with the idea of people being made from clay from the Judeo-Christian Bible which states that Adam was formed and sculpted from clay; the original Hebrew word for Adam in this form was Golem. Golem was Adam's name after he was sculpted but before God breathed the soul into him.

Many cultures other than Hebrew tell of a muddy Birth for humanity from the gods. The Apache legends tell of two creator Gods who wanted something to worship them and so they made people out of clay. According to Chinese mythology Nüwa molded figures from the earth, turning them into living people. In Egypt the Creator God, Kneph, is a potter and makes Humans out of clay on his pottery wheel. Sumerian Creation sagas show Enki the first Man created from clay.

"Enki then advises that they create a servant of the gods, humankind, out of clay and blood. Against Enki's wish the Gods decide to slay Kingu, and Enki finally consents to use Kingu's blood to make the first human...Enki assembles a team of divinities to help him, creating a host of *'good and princely fashioners.'* He tells his mother...Nintu (goddess of birth) will

stand by thy fashioning; And Nammu told
him that with the help of Enki (her son) she
can create humans in the image of gods."
—Samuel Noah Kramer, *SUMERIAN MYTHOLOGY*

But are Gods the only ones who can make living things out of mud?

Though mostly attributed to the Hebrews in popular culture, most famously being the Golem of Rabbi Loew in Prague, the concept of a living human making another living thing out of clay or mud is a worldwide phenomenon. The creation of a statue out of rock, mud, clay or stone which is then worshiped or brought to life is so prevalent it is hard to pass it off as impossible even to the most rational mind. Scientists have long held that rocks and stones are not living creatures, but there are those who protest these theories:

"In crystal we have a pure evidence of the existence
of a formative life principle, and although in spite
of everything we cannot understand the life
of crystals—it is still a living being."
—Nikola Tesla

Before we scoff at such notions, it becomes necessary to review some of the principles and theories of the creation of life itself. The fantastical tales of life emerging spontaneously from the Earth are not new and science has hotly been hunting the answers to the question of the origin of all life for a while. We find that many findings do indeed point to emergence of living creatures from the primordial soup of the mud. DNA, the building block of all life, is considered a liquid crystal after all, and may not be as unrelated to your diamond ring as you think. In early experiments such as the famous Miller-Urey work of the '50s an electrical charge was sent through soil and earthy mixtures to success-

fully create some of the basic proteins and building blocks from which life later formed. Out of a freaky Dr. Frankenstein-esque lightning jolt was crystallized the main ingredients for living molecules made only from the Earth and lightning. This work left a big question mark in the validity of the ability to make life from mud. There are more developed Scientific theories that ruminate life forms on our planet originally were composed of silicates and minerals all suspiciously found in these "dead" rocks and stones that crawl from the bowels of Mother Earth. These theories focus on Silica as a possible origin source for living molecules, rather than Carbon. In his work *Chemistry and the Missing Era of Evolution*, Cairns-Smith discusses this in great depth and investigation.

"Which crystal would be preponderant on primitive earth to possibly do such a job? Why, ordinary clay of course. Silicon dioxide in its myriad manifestations. ... Science fiction writers have long since fantasized about a silicon-based biosphere. But here silicon has been theorized to be the seed of life in quite another fashion. According to Cairns-Smith, crystals of silicon easily harbor organic impurities in them. With time, these impurities will grow along with the crystal...In time, what you will have would be an organic crystal. *Now* think about DNA, RNA, proteins and suchlike forming from such organic entities."
—Ashutosh Jogalekar, *IT'S CLAY TIME: THE ORIGINS OF "SILICON-BASED" LIFE*

Clay being alive suddenly seems more sensical now that there is that possibility. The famous physicist Schrödinger in his work *What is Life* came to the same conclusions as Cairns-Smith and agreed that DNA molecules probably arose from clay and silicates.

The Golems were made from clay or stone in all the cultures and brought to life by a Priest, Alchemist or Shaman type of figure who has the secret recipe for the breath of life. In most ancient places can be seen enormous statues of animals, Gods and humans. The Greeks and Pagans considered the statues of the gods they worshiped to be alive, and thus thought of as a "Living Statue." This concept is given credence in many instances. The name of the Sphinx in Egypt is "Shesep ankh," a word that translates as "Living Statue" or "Living Image." Ironically the term Living Image can be related to graven image, and these ideas all come from Idol Worship. The stories of something breathing life into a statue come up fairly often with idolatry; take the Book of Revelation for example:

"Because of the signs it was given to perform on behalf of the first beast, it deceived those who dwell on the earth, telling them to make an image to the beast that had been wounded by the sword and yet had lived. The second beast was permitted to give breath to the image of the first beast, so that the image would also speak and cause all who refused to worship it to be killed."
—*REVELATION 13:15*

The story of the breath of life in a statue has parallels in the examples of Daedalus, whose statues could talk. Vulcan made robot types of things to do his work for him. Prometheus created man from clay, while Demeter breathed life into them. Pandora was made from clay and Zeus breathed life into her.

Idol worship and making living statues eventually became expressly forbidden by Hebrews, Muslims and some Christian sects, and the story of the worship of the golden calf discovered by Moses carries the reminder that making statues come to life through cult worship became something that was frowned upon. Early Christians forced the

cults to break up, ceasing this behavior under threat of death for hedonism. The new rule becomes not to make Graven images of humans or animals under any circumstances, because it will make God jealous that you are trying to create something created by the creator. Even making buildings out of "hewn stone" was at one time only done by the Giants and not humans (see Cyclops entry). None of the listed living creatures of the Earth were to be made; only God could make those. But people still did it anyway; even Rabbis, who supposedly knew better, could not resist making idols out of the Earth and breathing life into them.

The word Idol comes to us from "eidolon" which really means an image of a ghost or specter. It also means a reflection in a mirror. It has a meaning of being an insubstantial image of something that is alive, like a projection. It is the thing but not the thing. This word is related to words like phantom and imagined. The Hebrew word Selem is often used and describes something more like a shadow projected from a real thing. This word, Selem, is the one chosen to describe the image that God makes us in of itself. Adam is made in Selem of God. We are like a Shadow projected of God in that case, so if applied to these living statues, similarly a living image is projected from the mind of a human and is made from the earth. It is a mirroring of the action of creation of human for humans to make a Golem.

There is even a little-known instance of Jesus Christ participating in Golem making that was told in both the Gospel of Thomas and the Quran:

"And when thou hast created from clay the likeness of a bird with My permission and thou hast breathed into it and it becomes a bird with My permission"
—*QURAN 5:110*

There were restrictions on making Idols of things that God had created; this was in the second commandment about Graven images. Since there were restrictions on making things that were copies of the Creator's creations, some scholars speculate if this was why Egyptians made animal-headed hybrids, to avoid breaking this law. As long as a statue did not depict an actual living creature, it was not in violation of Creator's law.

One aspect of how the Hebrews have interpreted the power to create something out of nothing is to attempt to imitate the creator through the use of the book and letters that describes creation, the Torah. To create things, the Jewish Rabbis of old would use different combinations of the Hebrew letters to arrange them into words (usually names of God). If this sounds similar to many types of witchcraft and spells, that's because it is. Those who have studied, say, Hermetic Magic, will recognize that most spells are arrangements of letters and numbers, sometimes into geometric shapes and forms (or magic squares and circles). This same process forms the basic Kabbalistic traditions, including Golem making. The first Rabbi to do this was named Elijah Ba'al Shem of Poland. He was a Kabbalist and according to his relative, he made a golem. He used a "Shem" or name from a combination of Hebrew letters and breathed life into a mud-made statue.

He was known as a "Ba'al Shem," master of the name.

The Talmud reports on others who succeded after him, so the infamous Rabbi Loew was by no means the only one to have made a Golem.

> "Creation itself…is magical through and through: all things in it live by virtue of the secret names that dwell in them."
> —Gershom Scholem

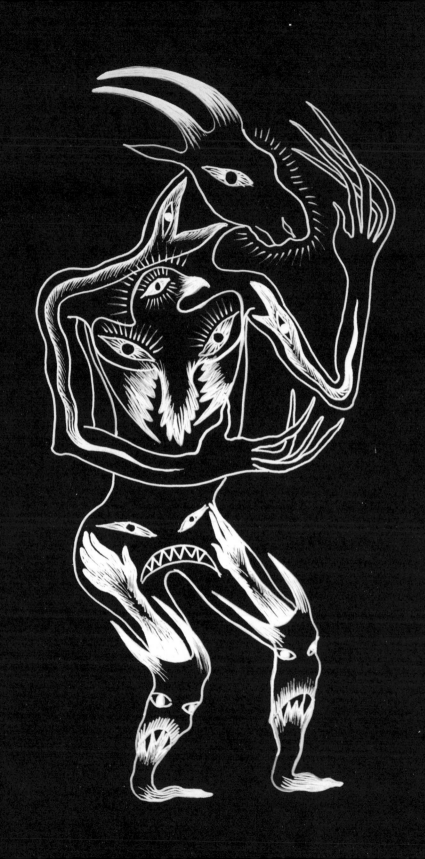

CHIMERA

"We are our memory, we are that chimerical museum of shifting shapes, that pile of broken mirrors."
—Jorge Luis Borges

The Chimera came to me through Chemistry. I was studying Biochemistry and genetics when I came across the name and became obsessed with the implications of this creature. A genetic Chimerism or Chimera is a single organism composed of cells from different zygotes, in effect making it several beasts contained within one. This can take a few forms in the natural kingdom, such as one animal with both male and female genes. Scientists have been taking advantage of Chimeric qualities in nature in order to do things like make human animal hybrids to grow Human parts on. Basically, the Chimera can be two or more creatures at once within its flesh and bones; there are even Human Chimeras, some living among us without even knowing they have an extra set of genes hidden inside their blood. I came across an article on a snake that was able to reproduce itself in an asexual fashion thanks to its Chimerism, which permitted it to produce parthenogenetic offspring. I also read some articles on human/cow hybrids that Scientists were beginning to create and quickly realized the reality of bestial amalgamations. The human cows were made by placing Human DNA into the hollowed-out cell of a cow and then zapping it with electricity. This made *The Island of Dr. Moreau* jump from a fantasy novel to an instruction manual.

Leaping back through time, we see that traditional definitions of the Chimera focus on this multiple gene aspect as well. Most define a Chimera as a multi-animal combination that is destructive and mon-

strous. The word itself lends from "year-old she-goat" and was used to describe the winter season. An odd moniker unless we are familiar with the Zodiac beast of the winter season, Capricorn, the goat creature hybrid who was a Chimera combination of a human that transforms into a goat with the tail of a fish. The Capricorn animal is thought to be a depiction of the God Vishnu by many and specifically a form he shapeshifted into in order to escape from danger. The latent animals within Vishnu were expressed in a moment of duress, like some activated Atavism of Chimerism that transformed his shape.

According to the traditional myths, the Chimera was a combination of a lion, a goat and a snake that breathed fire and lived in the hills and mountains of Kragos. It was a complete menace to the surrounding area, and would periodically descend into the village and kill and burn everything devastating the country side. The Chimera is the offspring of two primordial monsters, Typhoeus and Ekindna, and also gave birth to more monsters, one of those being the Sphinx.

There is a very ancient type of Chimera that lives, in the form of statues, all over Egypt and the Middle East. This Chimera was a guardian form of Amun-ra known popularly as a Criosphinx. There were several kinds of Sphinx hybrids with different heads and multiple animal ingredients. The Criosphinx had the head of a ram, the body of a lion and some had tails of serpents exactly like Chimeras described in the sagas. There are a staggering nine hundred Criophinxes with rams' heads, in Thebes, the heart of the cult of Amun. Amun was a god with blue skin, much like the other Chimera-esque god Vishnu who shared this trait. Although Amun was depicted in several other forms, the Criosphinx was an unmistakable mark of Amun worship and intimately linked to this God.

There is another fire-breathing lion in Egypt that destroys everything in a destructive rage as the Chimera, the Goddess Sekhmet. Some think it was Sekhmet who influenced the mythology of the Chimera.

Like Kali, who destroys in her blood fever, Sekhmet enters an angry fury that consumes everything in her fire. Sekhmet was around at least three thousand years before Greek versions of the Chimera, so word of her fables had plenty of time to reach their ears.

In more symbolic literature as time wears on, the Chimera was thought to embody an aspect of our minds. The Chimera came to be a beast that represents the Imagination itself, or a particular product of mercurial work in the Alchemical communities. According to Spinoza, the imagination is made of the animal spirits that move within the Cerebrum; these when taken together in their totality are the Chimera. Spinoza viewed the Chimera as a kind of "possibility" that could be true and so separated from myth because it is something that could happen, even if only in the imagination. This makes me think of the genetic possibilities above, how there is another DNA contained within that "could" become something else if the environmental conditions are right. The Atavism is how geneticists describe this, and we all have a history of genes of many creatures folded into our flesh known as "hox genes" that sometimes come out of hiding when a person is born with a tail, for example. The Chimera is really a kind of thing that latently exists. It is a creature that is a hidden potential that could be expressed both creatively and literally biologically. From these imaginings, the Chimera symbolizes the ability of the imagination to make monsters where there may be none. In this respect the Chimera is said by many artists and poets to be art itself and the true nature of the creative imagination which can be like a fire-breathing monster that will take over everything else. Descartes discussed the Chimera too in terms of its latent imaginative principle:

"Now as far as ideas are concerned, provided they are considered solely in themselves and I do not prefer them to anything else, they cannot strictly speaking be false for whether it is a goat or a Chimera I am imagining, it is

just as true that I imagine the former as the latter."
—Descartes, *THIRD MEDITATION*

Here the point is made that the imagined Chimera is true even if a real
Chimera is not. According to these philosophers, the Chimera is seen
like a prototype of the concept elucidated years later by the Quantum
physicist Schrödinger in his famous cat in the box scenario, the idea
that possibilities can all exist until proven otherwise.

Tales of the Chimera function as cautionary, however, and beg us to
consider the consequences of imaginations that are unrestrained and
undisciplined. Hopefully the scientists engaging in the creations of hy-
brids will take heed of these warnings and consider that just because
something can be imagined does not mean it should be made manifest,
lest the entire countryside be burned up in its uncontrolled release.

"According to Paul Diel, the Chimera is a disease of
the psyche, characterized by a fertile and unrestrained
imagination. It displays the perils of exalting the
imagination. The snake's or Dragon's tail represents
the way in which vain glory perverts the spirit; the goat's
body sexual fickleness and perversion; the lion's head
a tendency to dominate which spoils all social relation-
ships. This complex symbol might equally well be em-
bodied in the disastrous reign of a perverted,
tyrannous or weak ruler as in a monster
devastating the countryside."
—*THE PENGUIN DICTIONARY OF SYMBOLS*

Some of this caution was placed upon the action of fantasy and fanta-
sizing about desire-based thoughts, applied by some to the function of

sexual fantasy. The fin de siècle poets conflated the Chimera with the imagination and specifically sexual desire that can run rampant. The Chimera was a particular aspect of the imagination that was engaged when someone desired something so much that they began to think about it obsessively. Once engaged in this fashion, the sexual creative imagination could turn into something unhealthy and become more of a longing despair that craved for a thing in its thoughts rather than enjoying the fruits of the present moment and being focused in awareness of reality.

"I offer to the eyes of men dazzling perspectives with
paradise in the clouds above, and unspeakable felicity
afar off...I urge men to perilous voyages
and great enterprises. I have chiseled
with my claws the wonders of architecture"
—Flaubert's temptation spoken by the Chimera

It is a fine line between the latent powers of our imaginations being productive and empowering us to create incredible things never before seen like rocket ships, and the destructive desire for power, control, and domination through our imagined greatness. When not made real, our imaginings can become prisons where we simply waste away and become a ghost floating through a disdainful reality that can never match the beauty of the imagined realms. Here the imagination becomes a burden that weighs heavy upon us as we may never reach the heights of how our creative mind sees our potential when contrasted with our day-to-day existence.

EVERY MAN HIS CHIMERA
"Beneath a broad grey sky, upon a vast and dusty plain
devoid of grass, and where not even a nettle or a thistle
was to be seen, I met several men who walked bowed

down to the ground. Each one carried upon his back an enormous Chimera as heavy as a sack of flour or coal, or as the equipment of a Roman foot-soldier. But the monstrous beast was not a dead weight, rather she enveloped and oppressed the men with her powerful and elastic muscles, and clawed with her two vast talons at the breast of her mount. Her fabulous head reposed upon the brow of the man like one of those horrible casques by which ancient warriors hoped to add to the terrors of the enemy. I questioned one of the men, asking him why they went so. He replied that he knew nothing, neither he nor the others, but that evidently they went somewhere, since they were urged on by an unconquerable desire to walk. Very curiously, none of the wayfarers seemed to be irritated by the ferocious beast hanging at his neck and cleaving to his back: one had said that he considered it as a part of himself. These grave and weary faces bore witness to no despair. Beneath the splenetic cupola of the heavens, their feet trudging through the dust of an earth as desolate as the sky, they journeyed onwards with the resigned faces of men condemned to hope for ever. So the train passed me and faded into the atmosphere of the horizon at the place where the planet unveils herself to the curiosity of the human eye. During several moments I obstinately endeavored to comprehend this mystery; but irresistible Indifference soon threw herself upon me, nor was I more heavily dejected thereby than they by their crushing Chimeras."
—Charles Baudelaire

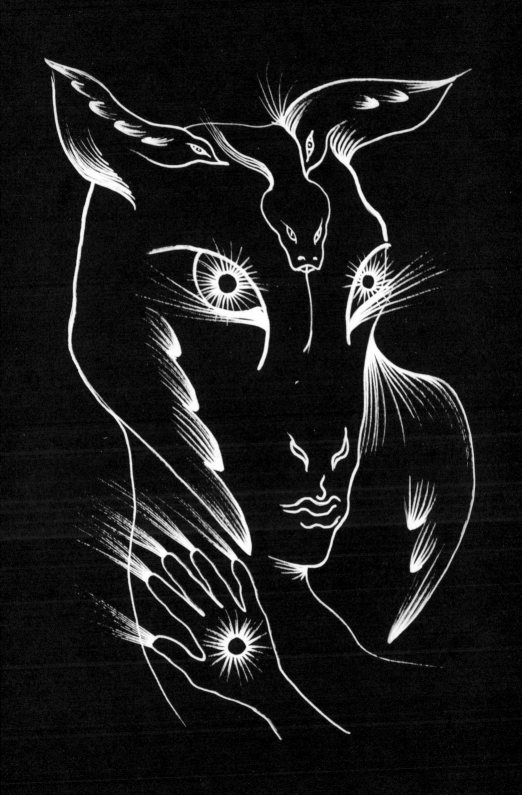

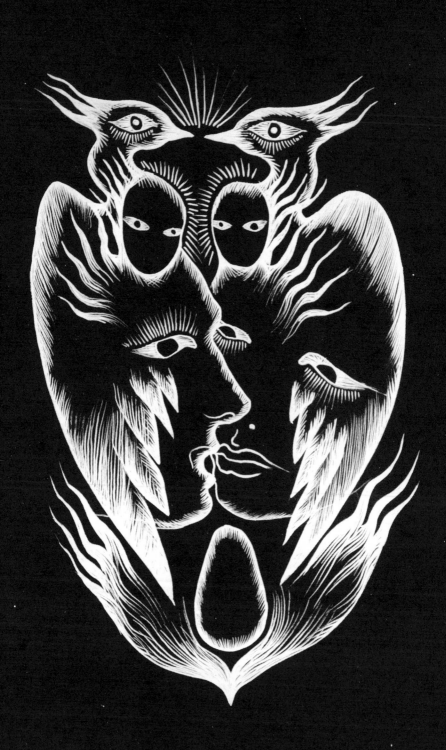

PHOENIX

"Two Eagles fly up with feathers aflame,
Naked till they fall to Earth again.
Yet in full Feather they rise up soon"
—*ROSARIUM PHILOSOPHORUM*

My personal relationship with the Phoenix arrived in a vision while involved in a meditation on death. I was "shown" what death was, or it seemed like that to me at the time. The image that appeared was unmistakably a rising bird. A hot bright ball of light emerged from darkness that had a perfect ring shoot out and encircle it, like the planet Saturn. The globe then began to expand within the ring and unfurled into a blossom like a flower. As it spread out it formed into a bird taking flight and ascended like a mushroom cloud. To me it looked like a nuclear detonation. Death was an expansion that extended past the external limit of an object as its energy grew too large to be contained within it and the power of all its contents spilled out into a bird leaping to the skies.

The fires of the Phoenix have been lighting the hearts of humans for an unimaginable amount of time. Truly they are immortal, as still they haunt our living minds. So many cultures refer to this bird of flame it is impossible to include them all, but perhaps they can be distilled into an essence.

A contradictory creature in true alchemical form, the Phoenix represents two completely different things simultaneously. It is at once a bird of life and creation while also holding the position of a bird of death and destruction. The Phoenix is a bird of light and dark, color and ash, male and female. A beast that holds oppositional forces united as one in its form and function.

Although the names given to the Phoenix vary slightly, they tend to converge around themes of Blood, life and death. The word Phoenix in English is where we get the root of the name Phoenicia, and here it means deep red or purple. It can be traced to a Greek word meaning simply blood-red. The title "Phoenix" describes a scarlet blood-red bird.

This distinct red factor belongs to a very famous bird in China, the Zhu Que. Zhu Que, also known as the Vermilion bird, is a Red supernatural bird, who is one of the guardians of the four directions in Asia. In Chinese mythology there are four creatures who are the watchers of North, South, East, and West. The Zhu Que guards the South and the element of fire. The Zhu Que is usually very red and covered in flames making it quintessentially Phoenix-esque. All over China there are red gates, or doorways, scattered across the landscape. The thresholds in front of most of the temples and buildings, are prefaced by this portal and these are dedicated to the scarlet immortal guardian bird. In fact, nearly every red door you might find yourself walking through can harken to this Chinese version of the Phoenix as its inspiration.

There is another form of this bird in China called the "Feng Huang." Most argue it is a different bird than the Zhu Que; however it is described in the same fashion, a scarlet-red fire bird affiliated with the sun. It is one of the figures in the Chinese Zodiac, commonly mistaken for a Rooster. The true translation of Feng Huang is "August Red Bird" which means bird of the sunrise. The year of the Rooster should really be the Feng Huang or Phoenix. I feel that Rooster came on due to the red coloration of most roosters and the Western translations or interpretations of this creature. The fact that the Rooster crows with the sunrise could also contribute to the intermingling identity of this bird affiliated with the rise and fall of the sun.

The red immortal bird was used by the Chinese alchemists and Taoists to describe a rock that was a key ingredient in immortality undertakings known as Cinnabar, also deep blood-red in color. Cinnabar is mercury

sulphide and was thought to be synonymous with the Zhu Que, providing a vital ingredient in the alchemical process. Cinnabar was also a dye for most Chinese lacquer and pottery due to its brilliant red coloration.

There is a stage in the alchemical process described in antiquity known as the "Rubedo" or the red stage. This stage is represented by the Phoenix in Europe and Africa as well as China and could have arisen through real physical chemical reactions of mercury and sulphur, two of the main alchemical ingredients that would produce a physical red color to emerge.

The Rubedo, or Iosis in Greek, was the fourth and final stage of the process, when the transmutation was complete. It was affiliated with gold, the sun and blood. The Reddening of the Rubedo is a stage when the two opposites are joined into the androgynous hermaphrodite. When the unification of these two opposites occurs, it leads to the conception of a child, or a new creation that did not exist before. Freemasons of old used a two-headed Phoenix, or Eagle, to show this unification of two adversarial polarities in much of their symbolism that can be found in archaic traces of American ideology as well.

> "These were the immortals to whom the term
> 'Phoenix' was applied, and their symbol was the
> mysterious two-headed bird, now called an eagle, a
> familiar and little understood Masonic emblem."
> —Manly P. Hall, *THE LOST KEYS OF FREEMASONRY*

According to Manly P. Hall, it was the Phoenix and not eagle that was the original symbol of America. Only later was it replaced by the Bald Eagle now commonly held as the American mascot.

The blood symbolism of the Phoenix is seen most clearly illustrated within the Christian mysteries of the Eucharist. If we imagine the Phoenix as having some kind of significance to blood immortality and

everlasting life we find a strong link to communion. In the Eucharist ritual it is the blood that, when consumed as food, confers immortality. There are many very specific references to the Phoenix and blood communion given in the old European and Egyptian Alchemical texts that predate Christian traditions, and the Phoenix could have influenced biblical lore in some capacity. Ancient engravings show the Phoenix piercing its own breast and feeding its nesting young with the blood that flows forth from the wound to provide them with nourishment. Later, this came to be depicted as a Pelican instead of a Phoenix performing this action, but in the earlier texts it was always a Phoenix feeding its children its own flesh.

In Dante's *Paradiso* there is a direct reference and connection to Christ and this type of breast-piercing pelican:

"Then sayd the Pellycan: When my Byrdts be slayne /
With my bloode I them revyve. Scripture doth record /
The same dyd our Lord / And rose from deth to lyve."
—John Skelton, *ARMORIE OF BIRDS*

The image of the pelican, who replaced the Egyptian Phoenix performing this action, feeding others with its blood, became very popular in Catholicism after St. Thomas Aquinas discussed it in his work and can be seen in many churches around the world.

When not feeding others its blood, the Phoenix had a curious diet that connotes a Christ-like relationship symbolically. Hebrew and Old Testament literature contain a few passages that refer to the food consumed by the Phoenix. According to Jewish legend, the Phoenix was a very picky eater whose finicky tastes may have saved it from death and conferred its immortality. My good friend Amit Itelman made me aware of the folklore version of this story. He recounted that while Eve convinced all the other creatures in the garden of Eden to consume the

forbidden fruit, as advised by the serpent, the Phoenix alone refused. This was due to its preferred food: Frankincense. Frankincense was among the first offerings made to Christ and was also one of the last, as it was used to embalm Jesus by Mary herself in his tomb in apocryphal tales. There is even a story of the Phoenix being on Noah's ark, and when Noah came around to try to feed it, the Phoenix replied something to the effect that Noah looked very busy and it didn't want to bother him with the labor of feeding it so it didn't eat at all. Some say this was because Noah didn't offer it Frankincense, while others indicate it was due to the fact that the Phoenix was so polite, it didn't want to put out its host in an act of self-sacrifice. In Egypt too there was a direct link between the Phoenix and Frankincense as it was often shown perched upon this sacred shrub.

For Egyptians the Phoenix was called the Benu, Ben Ben or Bennu Bird, described as a deep dark red color and represented by the sun. The Benu in Egypt is a symbol of Ra and Osiris and its image is a hieroglyph that represents the sun directly. The Phoenix here is described to be the soul of Osiris, the resurrecting God, and his ability to reincarnate is attributed to the Phoenix living in his heart affording him this immortal power. This also could be a blood reference, for what lives in the Heart but the blood? The root meaning of the word in Bennu is "to return" and the Bennu signifies the returning traveler. Other references to the Bennu bird involve a sense of self-creation, literally translated as "He Who Came Into Being by Himself."

Ben Ben has a dual meaning in Egypt and is also a term used for sexual copulation and consummation, to come together for conception, much like the Alchemical symbolism earlier referenced. The Ben Ben was the ability to conceive a seed in the womb. In the Book of the Dead, the Bennu is described as a seed that forms a life.

The most amazing thing about the mystery of the Ben Ben, however, lies in its attachment to the Pyramids. At the top of all pyramids in Egypt, there ex-

isted what were referred to as "cap stones" or a kind of tippy-top stone like a mini pyramid that sat at the peak of all the pyramids throughout Egypt.

The Egyptians called these the Ben Ben stones and they were affiliated with the Phoenix. There was much discussion of the Ben Ben of the great sun temple of Heliopolis in history as the cap of the pyramid, and it was said this stone was the concentrated point where the temple connected directly to God in consummated union. The descriptions of the Ben Ben stones were as dark black shiny rocks that reflected the light of the sun. Most of the Ben Ben stones were said to be made of meteorites made mostly of Iron, so would be naturally magnetic. A link to blood could be made here as at the center of this vital fluid is an Iron core.

The Phoenix or Ben Ben being a pinnacle reaching to embrace heaven can also be seen in the Obelisk. The Obelisk represents the Phoenix rising up to heaven. The word Obelisk comes from "snake" and is the long pillar of the serpent rising to the sky, topped by the Phoenix reaching for the sun.

The Ben Ben would perch on top of these pillars and pyramids as a bird on a tree. Ben Ben stones are said by the Egyptians to call out to God as a rooster crows to the sun in order to allow Spirit to enter the temple in a metaphor for an interaction between heaven and earth.

The Phoenix holds and carries the torch of the concept of immortality through its connections with the Sun and the blood of living things. The Phoenix beast conveys the thought that although death does indeed happen, the sun sets every day; the other thing that happens invariably is that life renews with every dawn. The Phoenix holds the blood of everlasting life in its chest as it flies through the sky on its daily journey from birth to death. Through the wild, fiery blood of this magnificent bird, whether metaphorical, Eucharistic, material Iron in a meteorite, or blood shed from the breast, the Phoenix tells us that there can be achieved a new life through the blood we share.

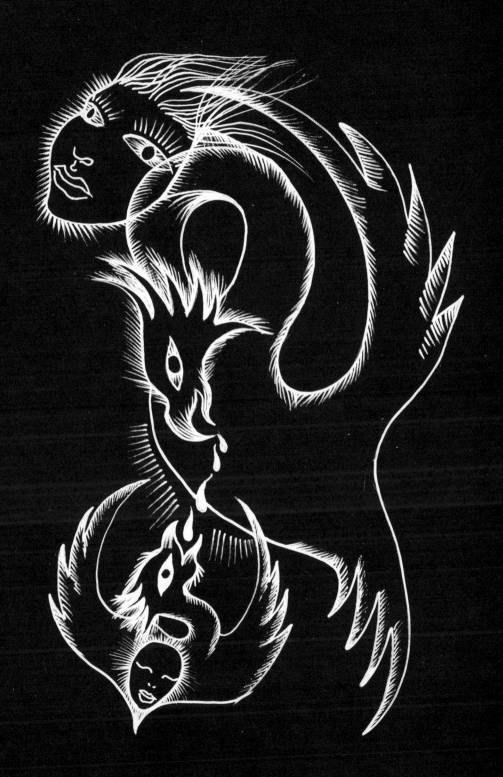

OANNES AND THE FISH PEOPLE

"Sea monster! Upward man,
and downward fish"

—Dante, *PARADISE LOST*

I grew up on a small Island in the Pacific Northwest. Many evenings were spent in the dark by the salty waters of the Puget Sound. On one such occasion, myself and some friends were having a bonfire on the beach. Admittedly, it was dark and we were drunk, but we all undeniably saw something on that special evening. We were talking, rather loudly and without restraint. Suddenly, several of us were distracted by sounds and movements in the water just a few feet away. Then someone shushed everyone, and we all turned silently to gaze at the water. There was something there, staring back at us. We shared what seemed like ten minutes of silence trying to figure out what it was. It was raised up a few feet out of the water. At first we thought it was a seal, but then it moved very strangely, off to the side in a kind of gesture that was not animal-like, but sentient. With a turn and swish it rolled over in the water, splashing up its tail for all of us to see as it swam away. Although we never found out the identity of the creature we encountered that night, we all knew it purposefully came up to the shore to watch us, and I was hooked on the legends of the Fish people ever after.

Descending into the cool depths of the water in our monster voyage we turn our attention to the Fish people. Most folks are familiar with the water creatures known as Mermaids or Mermen, shown in

traditional Bestiaries, but in esoteric literature we have the curious hybrid fish race who brought Humans knowledge and civilization. These were known as the Fisher Kings, though they have many names. These Fisher Kings are the Fathers of all modern Mermaid myths and deserve some attention. In most accounts of the Fisher king types, they are described as hideous, ugly and creepy, a far cry from the beautiful and beguiling Mermaids of today. They are more like Monsters.

The Fish people are pictured as half fish, half human hybrids that emerge from the ocean, or sometimes rivers. They are a bit like mermaids, but many wear the fish more like a cloak over themselves instead of the popular fish tail. In the stories of the ancients they bring civilization and knowledge to people about writing, language, agriculture, immortality and medicine. They exist in nearly every culture, arriving after a great flood to guide Humanity into the age of Civilization. The fantastical tales of the city of Atlantis are tied up in the Fisher Kings, and the Myths of the rulers of these species of fish people extend far and wide into antiquity.

In the Indian Lore, it is Vishnu who arrives in this form to save mankind. The Chaldeans, Babylonians and Greeks all have their version of the tale. In Sumerian myth the epic Flood story of Enki is very similar to the Judeo-Christian tale of Noah and his ark except in these older versions, Noah's character is half man, half fish.

These Human-fish hybrids were not just individuals though; according to Greek sources, there were entire races of them called the Musari, or Annedoti. They were famous in many countries and helped a great deal of people come up into more civilized forms of being rather than being savages. Some of the best sources of the remnants come to us from a fellow named Berossus who procured them from Chaldea.

"In the first year there appeared, from that part of the Erythræan sea which borders upon Babylonia, an animal destitute of reason, by name Oannes, whose whole body was that of a fish; that under the fish's head he had another head, with feet also below, similar to those of a man, subjoined to the fish's tail. His voice too, and language, was articulate and human...This Being was accustomed to pass the day among men; but took no food at that season; and he gave them an insight into letters and sciences, and arts of every kind...he instructed them in every thing which could tend to soften manners and humanize their lives. After this there appeared other animals like Oannes, of which Berossus proposes to give an account when he comes to the history of the kings."

—I.P. Cory, *ANCIENT FRAGMENTS*

In Mesopotamia they had "Uan" (some say this name is etymologically related to Oannes) whose character was part of a famous story of a sage sent by the God Ea to educate humanity. Portrayed as part fish, part man, "Uan" means the "gentle one," and has been correlated to Noah from the Hebrew Bible as their names have the same meaning. It could be that all these Fisher Kings found the land after some flood occurred and would appear to the landlubbers, who had maybe never seen a boat, as being sea creatures.

Native Americans had their versions of these fish-men hybrids, in some Northeast tribes they were called "N-dam-keno-wet," and in South America, the tale of the Popol Vuh and the very famous story of QuetzalCoatl, a serpentine messiah who comes out of the sea, both relate the Fisher King narrative.

"on the fifth day they appeared again and were seen in the water by the people. Both had the appearance of Fish-men"—*POPOL VUH*

Some of the most ancient records of these fish creatures come from China and here the fish beings are river spirits who bring civilization, math and language. The most widespread was a husband and wife couple named Fuxi and Nuwa. The two were intertwined in a sort of DNA-like shape. They are shown sometimes as serpentine but also like a fish in many of the older tomb drawings. They emerge from the River and bring the people of China all the trappings of higher knowledge.

The Greeks had Cecrops, a mythical half-fish king of Athens who was akin to Fuxi from China, having a kind of serpent-like tail in some artistic representations, but also sometimes as half fish. He was credited for making the city of Athens through his teachings on how to be civilized. He taught them to hold customs and rites and build cities.

There are extensive and fairly specific references to a Fisher King in biblical and Hebrew literature who was worshipped by an entire nation. His name was Dagon. Statues and artistic reliefs of this Fish man extended all over Phoenicia, into Persia, Egypt and the Middle East; he even had a temple in Gaza. Some researchers claim he was synonymous with the biblical King Nimrod, but none are certain. Much like Fu Xi, he had a female counterpart called Atargatis, a fishy fertility Goddess who was shown rather like Venus springing from the depths of the sea. Dagon has been one of the most discussed and controversial versions of these Fish people in more modern times due to the focus conspiracy theorists have placed upon this figure. Some place Dagon as originating in Africa from the Dogon tribe; from this area we get stories of the "Nommo," a group of spiritual Fish beings that instruct Humanity. According to the Dogon, the Nommo came into the sea from Heaven, specifically hailing from the star Sirius, also known as the Dog star.

In the Bible, there was a showdown between Dagon and the Ark of the covenant where the Ark was brought before Dagon in a face-off and the two were left alone together in a temple. According to the legend, by morning the statue of Dagon had done a face plant and was found toppled to the ground due to the power of the Ark. Of course, none could purportedly look upon the Ark and survive as the story goes, so it seems even the fish men were no exception to this rule.

The other connecting stream between the fish men and Church lore is Jesus himself. Many have argued that the Fish symbol and Greek title for Christ of "Ichthys" point him in the direction of affiliation with these beings, and there are some vestiges of Catholicism that could be reminiscent of this as well. Some believe baptism in the water could be a reference to the emergence of Oannes and that the Christian baptism is somehow recapitulating this. St. Augustine called Christ the great fish that lives in the waters, and there are scholars who feel the story of Jesus was emulating some of these earlier tales of Fish-men who came to enlighten people in the ways of being compassionately Human such as is reflected in the tale of Indian messiah Vishnu, the fish-man avatar.

Whatever the explanation is behind these fascinating Fishes, one thing is clear: they are undeniably a fixture in the consciousness and history of humans. If not taken literally to be a flesh-and-blood fishy beast, it is possible the Fish people could represent human evolution in these tales and how we became socialized instead of killing everyone, and learned to live in peace with each other. It's possible the fish-men came up from the seas of the subconscious minds of humans, as some force driving them to make more moralistic and character-based choices instead of relying entirely on their primitive minds for survival. The main theme in all the tales of the Fisher Kings is that they rescue Humans from their own animalistic behaviors of violence toward each other and develop in communities that live in harmony.

MINOTAUR

Into the chasm was that descent: and there
At point of the disparted ridge lay stretch'd
The infamy of Crete, detested brood
Of the feign'd heifer: and at sight of us
It gnaw'd itself, as one with rage distract.
To him my guide exclaim'd: "Perchance thou
deem'st The King of Athens here, who, in the world
Above, thy death contrived. Monster! avaunt!
He comes not tutor'd by thy sister's art,
But to behold your torments is he come."
Like to a bull, that with impetuous spring
Darts, at the moment when the fatal blow
Hath struck him, but unable to proceed
Plunges on either side; so saw I plunge
The Minotaur; whereat the sage exclaim'd:
"Run to the passage! while he storms, 'tis well
That thou descend."
—Dante, *INFERNO*

The Minotaur is a shameful offspring tale, appearing to show the harrowing consequences of inappropriate lust. Hailing from Greece and the island of Crete, the Minotaur myth has many layers to be unfolded.

The Minotaur was a man-eating monster with a human body and the head of a bull who lived at the center of a labyrinth. It was the child of Pasiphaë, wife of King Minos, and a bull that was sent by Poseidon. King Minos had prayed to the Gods for a bull and was given a beautiful, spotless white bull. The Gods asked in return that he sacrifice this bull, but he decided to keep it because he liked it so much. Then he tried to trick the Gods by replacing it with a less awesome animal, in a classic switcheroo maneuver. He was punished for this by the Gods who made his wife fall madly in love with the bull and lust after it, producing the hapless child. The word Minotaur seems to be a combination of the Beast's two fathers, King Minos and the bull, Tauros. There were many ancient superstitions that monsters were often born of the unions of humans and animals, dating back to the oldest texts of the Hindu Vedas, so some early pagans thought this could be a true tale. Although this is technically biologically improbable, I can't help but mention we are currently creating human-cow hybrids in our scientific laboratories making this myth more modern than ancient.

The bulls of those ages were of monstrous size. A species of bull known as the Auroch trampled the European earth up until around the 1600s and it was almost twice the size of the bulls we know today. The Aurochs were the largest land mammals of Europe. And so, from this union with a superbull, the Minotaur was born.

Some people compare this union to that of the myth of Europa and Zeus. Zeus fell in love with Europa, who was King Minos' mother. He came to Europa in the form of a bull; some think the Minotaur was King Minos himself. Europa came to Crete via Phoenicia and the Phoenicians worshiped a bull God; it could be that the story migrated to Crete via Europa. Bulls are worshiped in many of the ancient religions, understandably so if you were to run across an enormous Auroch. Some mythologists equate the *Minotaur* with the God *Baal-Moloch* who was prevalent among the Phoenicians. Both were offered Human sacrifices as they were thought to be cannibalistic. Phoenicia

and Crete are not very far away from each other, making it highly probable that the ancient bull god made it across the sea. The name given to the Minotaur could offer some insight here as well: he was known as Asterion. Asterion means star, a strange name for a man-eating bull man, unless you know about Phoenicia. Two of the main Phoenician deitiess, Astar and Astarte, were a bull and a cow couple. Since the Labyrinth and Minotaur is a tale of being lost, it mustn't be ignored that Asterion could be a literal reference to the stars. The stars were the best way to find your direction, after all, and there is a large star in heaven known as the eye of the bull, which is one of the four heavenly guardian stars of the four directions, so if you could find the eye of the bull in heaven you could find your way through the labyrinth of the world, without getting lost.

If we view the myth as less external and more internally, many have made the analysis that the labyrinth of Crete is a metaphor for the human mind, and perhaps due to this affiliation, there is actually an anatomical brain spot named the Asterion. It is a place where several of the bone plates meet and it makes a kind of star pattern on the back of the skull. The Minotaur could symbolize a place in your brain that lies at its center, or subconscious.

In the story, there was only one way to find your way through the mystery and that was to find the thread, Ariadne's thread to be precise. The symbol of this thread is to find some kind of pattern or organization within the maddening, chaotic endless twists and turns. The pattern in the dark and lost subconscious mind was logic and reason; it was through thinking itself that the lost soul emerged from the confines of the dangerous maze. The problem of the terror of the Minotaur had to be analyzed from a different vantage point in order to find the center and then make your way back out again. Scholars compared this to the solving of a Gordian knot. This might tie the symbolism of the Minotaur into that of the Griffin and Sphinx in terms of the inference of a "Conundrum," riddle or puzzle that one has to solve.

If it isn't some kind of mental Sudoku, the tale of the Minotaur could also have a more reasonable explanation. My favorite chunk of history surrounding the Minotaur and the island of Crete is the Bull Leapers.

This tradition hails from mirroring the stars themselves and the beautiful Pleiadian sisters leaping over the shoulder of the constellation of Taurus the bull in Heaven. In Crete, especially Knossos, the same area as the Minotaur myth, there were acrobats who were known as recortadors, or bull leapers, and these were depicted on art as far back as 1500 B.C. In Syria some objects were found depicting the Bull Leapers that dated to the seventeenth century B.C.

Most folks have heard of Bull fighting, the gruesome and violently ruthless taunting and eventual murder of a raging bull. Some scholars think this was an adulteration of the ancient Bull leapers whose story was much more graceful and inspirational than the bloodthirsty sport of the bull fight. The recortadors relied only on their own swift and sinewy strength to avoid being gored by the precious Aurochs who were never harmed in the performances. They would leap out of the way as the bull charged them, often mounting the bull as it passed by them. In a remarkable display of mastery the bull leapers were graceful and courageous, never harming the animal, but rather honoring their size and strength by pitting their own agility against it. The Vikings and Norse had their version of this type of Bull fight as well; the Rune "Uruz" represented the Auroch and the warrior pitting its strength against this mighty creature in a show of prowess that subdued but did not destroy the Beast.

There are those who think these bull mounters could have been what spurred the legend of the hybrid creature and the woman who fell in love with the bull. Artistic versions of the person leaping over the bull, or a Europa-type Goddess riding her bull could have been what eventually forced the two together into one beast as they came in to a dance with each other.

Bull leapers were thought to be acting ritualistically as a form of worship for the Bull cults mentioned earlier. There were Bull leapers in other areas besides Crete where the Bull cult was also found, like Anatolia, so it is quite possible this Acrobatic tradition followed the Bull adoration. The Ritual was considered a demonstration of the Human ability to master and domesticate nature, even in its most dangerous and threatening forms, with ease and agility. The Human Triumph over the animal is always symbolic of our growth into maturity and divinity. If the Bull Leapers were the source of the Minotaur legends, the message was one of not being gored by the hostile environments we might find ourselves in, but rather finding some artful, passionate, enjoyment and interaction with them. The occult teachings are rife with tales of how domestication of your inner beast leads you out of a maze of confusion to tame the outer world of the forces of Nature. Once self-mastery is achieved, even a gigantic raging bull galloping toward you need not send your mind into a lost chaos because one could deftly maneuver such a threat using logic and skill.

JUGGERNAUT

Every living being is an engine geared to the
wheelwork of the universe. Though
seemingly affected only by its immediate
surrounding, the sphere of external
influence extends to infinite distance.
—Nikola Tesla

I first became familiar with the Juggernaut as a beast when I was a pre-teen and getting involved in playing Dungeons and Dragons. I had seen it in the Monster Manual and it grabbed me as something very powerful and stuck in my mind. The concept of something that is unstoppable holds a good deal of appeal.

The Juggernaut is famous for being able to crush and crash through everything in its path, laying waste to all the obstacles it may come across. Anyone who has ever met with a gigantic roadblock can see how attractive the force of will contained in this beast can be. The Juggernaut is a thing that does not give up, it does not stop; like the impossible perpetual motion machine, once you get it going, it just goes and goes and goes.

The Juggernaut usually has two components to its symbolism, one being a large or God-like entity, and the other being a chariot with wheels. Traditionally, Juggernaut types of beasts are Lords riding upon a chariot. The Name comes from Sanskrit and was applied to a God who was kept in a temple most of the year, but then periodically paraded around town on a huge wheeled vehicle that rolled with a tremendous force and momentum due to its weight and size. The Juggernaut is usually really big and moves very fast.

The Sanskrit word "Jaganntha" is eerily akin to "giant," and its translation means a lord as big as the universe, or "Lord of the Universe." If not directly related in the etymology, these two words have similarities in terms of size and strength.

Jaganntha also meant a combination of humans and animals all together, or like everything combined in totality, as part of the word was from the Sanskrit "jagat" meaning "the whole world, men and beasts." The force of the Juggernaut had power over man and beast alike. It was something that could influence the whole Universe.

Other ways the Juggernaut is large in stature and Beast-like can be found in the use of the Elephant to represent it. Another form of this God is Ganesh in Hindu culture. Ganesh is known as the destroyer of obstacles and roadblocks and is also affiliated with the chariot or vehicle with four wheels that is synonymous with the Juggernaut. Ganesh is the God that is approached when you need something removed from your path or annihilated completely. Ganesh, in typical elephant rage form, simply charges and tramples through everything leaving nothing but an open road in its wake.

The festivals held at the temples of Ganesh and the Juggernaut each year vary, but one of the most famous in India is the Chariot Festival in midsummer. The Juggernaut God or Ganesh is put on top of a gigantic chariot with large wheels that is very heavy and picks up a lot of speed. In the historical accounts in India sometimes people would either accidentally or sacrificially be taken under the wheels of this display and lose their lives to the unstoppable God. Constructing these enormous wooden carts made a real God who could crush whatever was unlucky enough to lie in its path. This also gave birth to the idea of the word Juggernaut, meaning an unshakable devotion, or sacrifice to a God. This was sometimes called Bhakti in the Hindu tradition to refer to a religious Zealot willing to give their lives for some concept, idea or

religion, as the devotees would fling their bodies to their deaths to feed the juggernaut.

> "Drive your cart and your plough over the bones of the dead."—William Blake, *PROVERBS OF HELL*

This Monster also embodies a trump card in the divination method the Tarot. The card "The Chariot" represents the Juggernaut, and also Ganesh in its Archetypal symbolism. In traditional translations, the Chariot card represents overcoming obstacles, victory, clearing paths and movement, all attributes of the Juggernaut beast and its supernatural abilities.

This devotional nature and aspect of human sacrifice to the Juggernaut deity came to give it an affiliation with a nefarious God of flesh sacrifice named Moloch. Moloch is most well known due to the conspiracy theories surrounding hidden activities of politicians and rich people at places like the Bohemian Grove and Illuminati cult events.

Although the Moloch isn't usually on a cart, it too is known as having a crushing and destructive force that can't be stopped. Instead of an elephant, it is depicted to be a trampling Bull, rather like a minotaur but huge, and has the same cannibalistic characteritics of the Minotaurs in that it eats human sacrifices. Moloch goes back in history as far as the Phoenicians and the Canaanites.

The name Moloch is based on the root "mlk" or Melek which means "king," or "Little king." There are several gods with names based on this root, also associated with Moloch, such as Malkam, "great king." Sometimes this crown, or kingdom, that is affiliated with the God Moloch comes from an ancient tale of passing through the fire of some kind of hardship. There is another monster who takes on this title known as the Basilisk.

BASILISK

"And in the livid night there creeps a basilisk, spawned by the moon after its strange fashion. The moon—eternally barren—is its father, but its mother is the sand, barren likewise: this is the mystery of the desert. Many say that it is an animal, but this is not so, it is a thought, growing there where there is no earth and no seed: a thought which sprang from that which is eternally barren, and now assumes strange forms which life does not know. This is the reason that no one can describe this being, because it is like nothingness, indescribable."

—Hanns Heinz Ewers, *ALRAUNE*

The Basilisk story came to me through my ancestry. I have always been fascinated with my forefathers and gather information on my lineage at every opportunity. The Basilisk entered when I met Paul Nugent, a distant relative on my Grandfather's side, who told me of the story of our family crest, the Cockatrice. My Grandfather's family had come from Ireland originally and my relative told me of a book that had a lot of good information on our bloodline called *The Green Cockatrice* by Basil Iske. The contents unravel the history of the

Nugent family and how one of its members was possibly the original William Shakespeare. Regardless of the truth of the work, it set me on the trail of the Basilisk to explore this creature and what it was.

I went through the history of the claims of its hypnotic stare and the usual descriptions of a snake-like beast born from the Rooster's egg, but I was having trouble understanding exactly what it meant, so I started investigating the names it goes by to get some clues. The word Basilisk, much like Moloch mentioned above, translates to "little King." It earned this name due to a Rooster-like crest upon its head that looks like a crown. There are modern-day lizards who have extra skin on their heads in this manner, such as the basilisk lizard who can also run over the surface of water.

This Rooster Crest on the beast's head also connects it to another of its forms and names known as the Cockatrice. The Cockatrice is shown as part lizard and part rooster, with the same crest. The cockatrice and Basilisk have many of the same features and crossover; some folks debate that they are synonymous but generally they are thought to be the same creature. The word Cockatrice is rooted in the meaning of a heel or foot walking or treading on something. It can also mean tracking something on foot like a hunter.

If we go back to Ancient Egypt, the Basilisk is known by the name ichneumon or echinemon and was said to be the enemy of the croco- dile and the asp. This was more of a mongoose species and it would eat poisonous venomous things. The funny thing about the name Ichneumon is that it also means "tracker," giving it the same meaning as Cockatrice. The echinemon was a beast immune to the stare and venom of snakes and could eat reptiles and their eggs. Some versions of the stories say the reason it was the enemy of the Crocodile was because it could eat its eggs, thus destroying it before it was even born. Along these same lines the Basilisk was known to be immune to all other serpents and deadly creatures in European lore; it was fearless

and dominated all of them. The "Little King" title was said to also be due to the fact that it ruled over all the reptiles. It was their enemy and destroyer. Thomas Bulfinch explores the concept of the Basilisk as the king of the serpents, ruling over them, he says:

"The Basilisks were called kings of serpents because all other serpents and snakes, behaving like good subjects, and wisely not wishing to be burned up or struck dead, fled the moment they heard the distant hiss of their king, although they might be in full feed upon the most delicious prey, leaving the sole enjoyment of the banquet to the royal monster."

In this symbolism, the Basilisk is something that treads upon all the other serpents. In esoteric and religious literature, a crowned being treading with its heel upon a serpent is a specific reference to a victory over evil forces. The etymology of Cockatrice contains the words Heel and tread simultaneously: calcatrix, from Latin calcare "to tread" (from calx (1) "heel"; see calcaneus, as translation of Greek ikhneumon, literally "tracker, tracer").

The Constellation of Hercules is placed in heaven with his heel over the head of Draco, the poisonous serpent, to illustrate this symbol of treading over the serpent in victory. We see this most popularly shown in the vision of the Virgin Mary with the Red Dragon of the Apocalypse. There are many images of Mary that show her treading upon a serpent, or with a snake under her heel. These are predominant in the Catholic illustrations. The famous virgin of Guadalupe shows Mary with a dragon under her feet in this manner. In these visions Mary is victorious over the snake Satan, and reclaims herself from his temptations of the flesh.

The Basilisk also shares an esoteric property with Mary, that of the virgin birth of Parthenogenesis. In the history of Alchemy, there exists much literature on making living things in the laboratory. This is Man copying the Creator, trying to make life, like Dr. Frankenstein, and continues in modern times. The Basilisk was one such creature that the Alchemists claim to have created by their own hand. Some versions of birthing a Basilisk had to do with taking menstrual blood and sealing it up in a vessel of some sort, like a makeshift egg, and then keeping it incubated in the Earth under the ground. From this perspective, the Basilisk is born parthenogenically from the most feminine energy that there is, the fertile Earth mother. Earth births happen surprisingly often in ancient tales and in the Greek myths especially there are numerous mentions of growing creatures in this way, through blood or other Human fluid being spilled into the Earth:

"As they struggled, Athena and Hephaestus, some of his seed fell to earth, and from it a boy was born, the lower part of whose body was snake-formed. They named him Erichthonius, because eris in Greek means 'strife,' and khthon means 'earth'." —Hyginus, Fabulae

According to the Alchemists, there was a condensed spirit in the menstrual blood that could be raised out of it through fermentation, like fermenting grapes to make wine. There were actually two creatures that could be made in this manner, the male version being the Homunculus. The Homunculus creation uses sperm instead of menstrual blood, that is then prepared by a similar process. Both these beings are made outside a body, from the bodily fluid containing the egg or sperm of a human.

Some related the Symbol of Mary overcoming and treading upon the serpent, or Red Dragon in the apocalypse, as a victory over the influence of her own menstruation. There are of course many taboos surrounding

menstruation, and the Basilisk could have represented the idea that a demon was thought to take over women on their period giving them the power of the evil eye. It was said that the Basilisk obtained the ability to kill with its stare from the Menstrual blood it was created from, due to the tendency of menstruating women to feel negativity toward others:

"So you see it is concerning a Basiliske,... he carries his poison in a most secret manner in his eyes, and it is a conceived poison, not much unlike a menstruous woman, who also carrieth a secret poison in her eyes, so that only by her looks a Looking glasse is fouled, and tainted...But to return to what I proposed concerning the Basiliske, by what reason, and in what manner he carries poison in his looks, and eyes; you must know that he hath that property, and poison from menstruous women, as is aforesaid. For the Basiliske is bred of, and proceeds from the greatest impurity of a Woman, viz. her Menstrues, and from the blood of [her] Sperm, if it be put into a gourd glasse, and putrefied in Horse dung, in which putrefaction a Basiliske is brought forth."
— Paracelsus, *DE RERUM NATURAE*

While seeming to be a very sexist and ridiculous concept that men should be afraid of a woman who is menstruating, deeper probing shows that the idea trying to be conveyed here is rather one of a tendency in humans to cast judgment upon their fellows. Through history it has been inferred that Women are more likely to fall under this particular sin, judgment of others, and especially can enter into it while menstruating. It seems like more of a warning that because women hold the power of creation within them, they should be more cautious regarding their hateful thoughts lest they manifest them and give birth to some terrible creature.

"Tostado's Paradoa, for example, explicitly links the
visual power of the basilisk to that of wolves and
menstruating women. All three are said to have the
ability to 'fascinate'—that is to work harmful magical
effects by means of visual emissions."
—William R. Newman, *PROMETHEAN AMBITIONS:
ALCHEMY AND THE QUEST TO PERFECT NATURE*

This statement was echoed by many of the male alchemists through-
out the Middle Ages. Ironically it was never mentioned that they too
might be hatefully judging the menstruating woman, so they fell into
their own trap, judging what they felt was the sin of the woman and
not looking into their own failings. The pit of the hypocrite is difficult
to escape.

"You hypocrite, first take the plank out of your own eye,
and then you will see clearly to remove the speck
from your brother's eye. Why do you see the speck
that is in your brother's eye, but do not notice
the log that is in your own eye?"
—*MATTHEW 7:3*

The concept of a sinful stare viewing the sins of others could be
at the root of the Medusa myth, where she also has a deadly gaze
that is cast upon others. The only cure for this particular type of sin
is to reflect back upon the one casting it, so that they can see they
are no better or worse than those they are judging. Wrapped within
the story of the Basilisk is a moral allegory of casting a judgmental
gaze upon our fellow humans, and a warning to menstruating
women not to let it get the better of you during this potent and creative
time of releasing blood into the Earth.

"Sin is a basilisk whose eyes are full of venom. If the eye of thy soul see her first, it reflects her own poison and kills her; if she see thy soul, unseen, or seen too late, with her poison, she kills thee: since therefore thou canst not escape thy sin, let not thy sin escape thy observation."

— Francis Quarles

As long as you see your own errors, you will not fall into hating other people and projecting your own problems onto them. We learn the lesson of the Basilisk when we remove the judgment of others through the understanding that we ourselves are full of mistakes and so have no place to view people in a bad light or with a hateful eye.

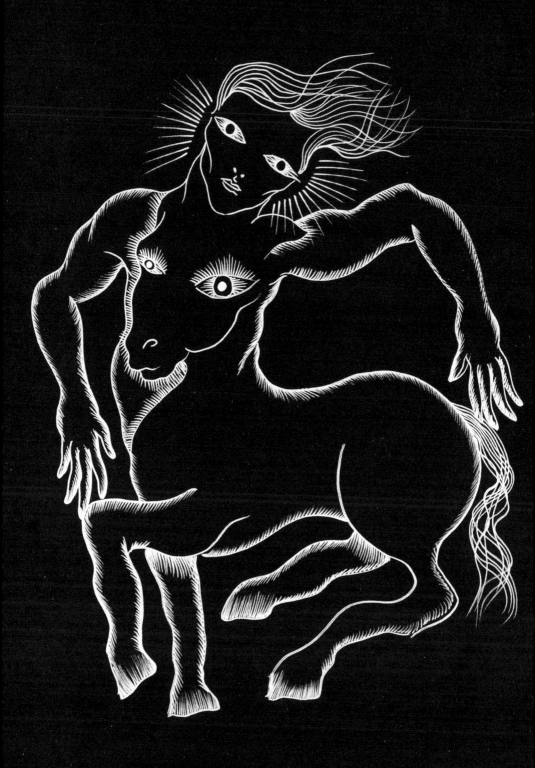

CENTAUR

Centaurs and Lapithae:
Now rushes to the feast the nuptial tide—
Centaurs and warriors drunken, bold and fair;
And flesh heroic, in the torches' glare,
Immingles with the Cloud's sons' tawny hide.
Jests, tumult, screams 'Gainst black-haired breast
the Bride, Her purple rended, struggles in despair,
To hoofs' hard blows the bronze rings through the
air, While crashes down the table in its pride.
Then one upsprings to whom the mightiest bow;
A lion's muffle frowns upon his brow,
Bristling with hairs of gold. 'Tis Hercules.
Whereat, from end to end of that vast space,
Cowed by the fury of his wrathful face,
The monstrous, guilty troop, loud snorting, flees.
—Jose-Maria de Heredia

The Origin tale of the Centaur is sad to say the least. Lechery, deformed offspring and Bestiality make up the story of this half-beast hybrid. The Centaur is a dark tale of loneliness and battles of the lower animal nature with the higher faculties of humanity.

There are several versions of the story, and differing interpretations of the meaning of Centaurs. The main narrative for their birth involves a

morally questionable father and a black fog of a mother. King Ixion, the grandfather of the Centaurs, went kind of crazy and Zeus felt bad for him, so invited him to a party at Mt. Olympus. Zeus was quite pleased at his act of kindness toward him and showered him with a good time. But Ixion could not keep his hands to himself as the evening wore on and got fresh with Zeus' wife Hera. Zeus was pretty peeved at this tactless action and punished him by making a fog woman who looked like Hera to trick him into having sex with her. Well, it worked and he was quite shamed, and the fog woman, Nephele, had a child as a result of the union. This child was deformed and hated among humans; its name was Centaurus. Centaurus could not find any place he was accepted, being hunchbacked and a frightful sight to look upon and so, outcast, he fled to a mountainous area populated by wild horses. The horses became his only friends and he mated with them, making his offspring the Centaurs.

This woeful recounting could hold more to it than meets the eye when we delve into the real history behind it and not just the mythology. According to many scholars, the Centaurs were actually a race of people who really lived. They were horsemen and kind of like cowboys. They hailed from the mountains and forests of Thessalian Magnesia in Greece and were called the Kentauroi. The Thessaly region of Greece was famous for its horses, so probably there was an exceptional bunch of Mustangs who populated the area. It seems there were not many humans who rode on horseback in ancient times, it was a bit of a spectacle, and so as you can imagine if you were a group of folks who had never seen anything like it before, you might just see the people and horses united as one fused beast as they ran toward you in battle. A terrifying sight to be sure.

In addition to being cowboys, there were a fair amount of these Centaur folk who were geniuses and people would travel from far away to learn from them. One of the most famous was named Chiron, which is where we get the word for hand as he was a surgeon. Chiron figured

out the art of animal husbandry and invented several types of surgery. He was very good with his hands and manners, and trained people far and wide in these arts according to the stories. There were some learned philosophers of renown also from this group that became known as teachers to many, perhaps where the association of Sagittarius the centaur in the zodiac with higher learning and philosophical pursuits arose.

In the history of the Kentauroi there is a recapitulation of an inescapable inheritance of the sins of the fathers and the origin myth of the Centaurs. The end of the race of the Kentauroi came through debauched behavior akin to their ancestor Ixion in a fit of uncontrolled and culturally unacceptable animalistic behavioral issues at a party.

There was a famous war recorded in history called the Centauromachy between the Kentauroi of Greece with the Lapith tribe who lived nearby. The Lapiths were also involved in the Trojan War in the legends. It is important to mention here that the originator of the story, King Ixion, was a Lapith himself, so both groups were brothers of a sort with a common bloodline.

This battle was legendary and became the fodder for many artists throughout the ages including Michelangelo.

The war was started when the Kentauroi were invited by the Lapiths to a wedding. It was well known that the Centaurs could not hold their liquor and once they had become drunk at the party they went nuts. In paintings, the incident is depicted as breaking out into a rape orgy where the Centaurs just decided to get handsy and take their liberties with whatever happened to be sitting next to them. Of course, this found ill favor with the Lapiths who then made a vendetta against all centaurs, and from this scene of lusty gore, the Lapiths went on a campaign and did not stop until all the Centaurs were dead.

In both the real-life and the mythological themes of the tale of the Centaur, the key point seems to be the troubles caused by the indulgence of the lower animalistic parts of ourselves and how social problems arise through breach of etiquette when we do not behave very well. In both instances, there is inappropriate lustful entitlement and drunkenness to a state of incoherence. The poor choices of the Centaurs in their fits of bodily possession seem to be what caused their extinction and disapproval from the surrounding regions, despite their equally valuable and virtuous contributions to society through their high-minded doctors and philosophers. The story of the Centaur could be boiled down to "mind your manners," especially if you have been drinking.

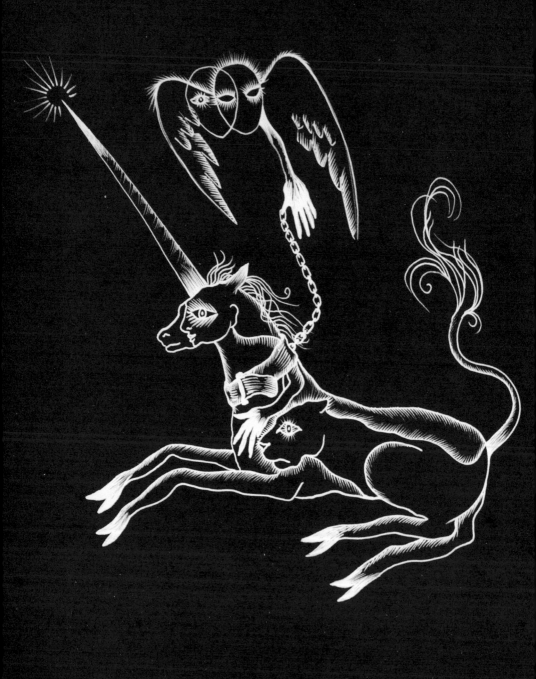

UNICORN

His glory is like the firstling of
his bullock, and his horns are like
the horns of Unicorns
—*DEUTERONOMY 33:17*

The mysteries of the Unicorn were revealed to me through a series of synchronistic events in 2015. It was November, near my birthday, and the moon was set to be full exactly on the day of my birth. My children and I were reading books together before bed, and at that time the story was *Blizzard of the Blue Moon* by Mary Pope Osborne. The book told the tale of two small children who have to save a Unicorn that is trapped in a tapestry. As the story unfolded, it was revealed that the Unicorn had the exact same birthday as mine, which was only a few weeks away in real time. The Unicorn in the novel had to be freed from the tapestry on the full moon, which was also on its birthday, and there was a full moon in real life approaching shortly.

The next day, my daughter was looking in a different book about fairies and saw a Unicorn tapestry in one of the pictures. She asked me if we could buy it because it reminded her of the story we had been reading of the Blizzard of the Blue Moon. It was a picture of a very famous tapestry known as "The Unicorn in Captivity." We went online to see if we could buy one, but they were all too expensive so I told her we couldn't. That night we kept reading the Unicorn story, and discovered that the tapestry the Unicorn had to be freed from was the very same "Unicorn in Captivity" my daughter had wanted earlier. We all started laughing at how crazy it seemed for that to happen, and my daughter said again how badly she wished we could have that tapestry ourselves. The following day I was walking around in the local Goodwill store, and there before me was, believe it or not, the

Unicorn in Captivity tapestry, a really nice one, for sale for only four dollars. I purchased the tapestry and then began to research its history and meaning.

In the tapestry is shown a Unicorn chained to a tree that is enclosed by a fence. The Unicorn appears to be bleeding from several wounds, although some argue it is juice from the pomegranate tree to which it is chained tightly. The Unicorn has a perfectly pleasant look upon its face and seems not at all perturbed by its predicament. Although tethered to a tree and constrained by a fence, the chain is not secure and the fence is low enough to leap over, implying that the unicorn could escape if he wished. Clearly the confinement is a happy one, surrounded by ripe pomegranates in the tree that are symbolic of marriage and fertility.

There are a lot of plants pictured in the scene surrounding the beast, most of which also hold affiliations with fertility and sexuality, seeming to add to the symbolic representation of some kind of union. The more I read, I found many of the opinion that this particular image was synonymous with the Crucifixion of the Christ. Some feel the unicorn trapped within the confines of the fence was meant to symbolize the acceptance of its fate, just as Christ faces his predicament on the cross. Here the Unicorn is sealed within its situation and comes to peace with its entrapment just as Christ feels acceptance of the suffering of his flesh. The Unicorn has decided to simply endure the situation and be still amongst the plants and Trees.

I continued hunting for research, delving into the Alchemical representations of the Unicorn. In esoteric symbolism, the Unicorn is affiliated with mercury after it has become fixed or stabilized as a result of the Alchemical process; here it is the hermaphroditic quality of mind. Mercury is known as a very volatile metal that is hard to make solid since it prefers to be liquid at room temperature. Carl Jung uncovered that mercury was connected with the alchemical property called the "Monocalus":

"Presumably derived from one stemmed, but more probably a misprint for monocolus, 'one-footed,' or from the late Latin monocaleus, 'having only one testicle, semi-castrated.' Monocaleus might be a reference to the androgynous nature of Mercurius. The conjecture Monocerous is possible since the unicorn signified Mercurius and was well known in 16th- and especially 17th-cent. alchemy."
—Carl Jung, *MYSTERIUM CONIUNCTIONIS*

Manly P. Hall brings this up in his work *The Secret Teachings of All Ages* and speaks of the Monoceros in relation to Alchemy as well. The Unicorn in this respect symbolizes the union of mind into a hermaphroditic being, displayed by the female unicorn who has a phallic horn and is sitting still as the mind comes into a fixed state, no longer volatile and shifting as a liquid.

In the esoteric mysteries, the Unicorn was adapted as a symbol of the illuminated spiritual nature, and many viewed the horn to be representative of the pineal gland or third eye which had become emergent. To many, the horn represented a mind that was one-pointed, or had a single focus, and that focus was God, or the supreme being. When the practitioner's mind was able to hold that single focus, that one thought above all others, the mind would ascend like a horn reaching to the sky. This ability to concentrate brought about a change in the mind itself and raised it up to another level of being, the level of the Unicorn. Similar to the point at the top of the pyramid, or obelisk, the tip of the horn is where everything becomes concentrated, and it contains a lot of power. This could be what led to all the legends of the medicinal properties of the horn of the Unicorn. Horns in general have been used in Chinese medicine, and folk medicine

preparations for centuries as ways to clear heat, toxins and poisons from things, and the horn of the Unicorn was no exception.

Unicorns could also confer the knowledge and wisdom gained from stiilness of mind to others in many traditions. In ancient China, their version of the Unicorn, the Chi'lin, gave wisdom and purity to the early founders of Chinese civilization. In China there are four sacred, supernatural animals that guard the four directions: the Dragon, the Phoenix, the turtle with a snake, and the Unicorn. Sometimes the Unicorn would be a White Tiger and these two seem to be interchangeable. In the Chinese Creation Myth, these creatures helped make the world and then later assisted humans with making civilization.

Fu Xi, the half man, half snake/fish who is credited with bringing wisdom to the people of China, received a lot of knowledge that could assist humans in their evolution, but he had no way to keep track of it so that it would be preserved. According to the legend he was lamenting the fact that all his knowledge would die with him, unable to share it, while he was sitting by the river. He sat by the river for a long time until all his thoughts had left him, and then his mind became still. Suddenly the Chi'lin Unicorn appeared before him and gave him the secret of language and writing so that he could preserve and record his teachings that all might benefit. This is when the Lu Shu, or the magic square, was made, and the I Ching was written down. The language given by the Unicorn to Fu Xi in the legend was one of graphic symbols, today called the Oracle script; some of the earliest samples unearthed to date go all the way back to 6500 B.C. It is said that Fu Xi attracted the Unicorn because he had stilled his mind into a pure and virginal state like the flowing water of the river. He had made his mind like the Unicorn, calm and peaceful, thus the Unicorn was attracted to him and the two came into a relationship together. Many scholars believe it was from these earlier Asian allegories that we get the imagery of the Virgin and the Unicorn. The Virgin simply represented one who was pure of thought and still of mind.

These concepts were found in ancient histories of Indian tales as well, and most of the Greek Authors placed Unicorns as coming from the Indus Valley area. In this region, we find Alchemical texts and clay seals with Unicorn images on them dating to around 2500 B.C. In the Indian Alchemical works, the Unicorn is directly related to mercury, and the metaphor of the Virgin luring it to her is thought to relate that anything that mimics or mirrors the same state has a magnetic pull to manifest the Unicorn through an attraction. David Gordon White discusses this phenomenon in his work *The Alchemical Body*:

"Upon seeing a well-adorned maiden, who having bathed
after first coming into season, mounted upon a horse,
mercury, which is found in wells, becomes possessed of a
desire to seize her, and rushes up out of its well.
Upon seeing it she gallops away. The mercury pursues
her for the distance of one Yojana. When that mercury
which is born of Siva quickly returns to the well,
it is caught in troughs dug in its path."
—Sivanatha, *SIVAKALPADRUMA*

The Mercurial well spoken of in this passage is the mind brought up out of its stillness and drawn forward by the desire for the Virgin, because it sees itself in her.

If the Unicorn is the representation of mercury and the mind, then the tapestry depicting it in captivity peaceful and still is really just showing a state that the mind must achieve in order for the alchemical work to be realized, a state of peaceful acceptance. A mind centered in its enclosure, aware and unreactive at its situation. The Unicorn encased within its secret garden is embodying the willful submission and stilling of the mind into peace. It is the soothed savage beast unreactive and calmly domesticated to be able to receive wisdom.

WEREWOLF

What is that lamp
which lights up men,
but flame engulfs it,
and wargs grasp after it always.

—Odin's Riddle

There are few creatures on Earth cast in the role of the villain more often than the Wolf. Terrifying variations of this creation of nature, shifting forms and always consuming flesh, fill humanity with mortal dread. For some reason, the wolf above many other man-eaters holds our attention as a true threat even if we have never actually seen one in reality. The Nocturnal, carnivorous lunar-driven nature of the Lupus holds us tightly in its bonds, transfixed and fascinated by it. If the danger of being eaten by a beast isn't bad enough, the Werewolf adds on the unpleasantry of being eaten by another Human who is Bestial. Most Werewolves devour or eat people, so are considered to be cannibals. The flesh-eating cannibalistic tendency of the Werewolf is consistent in most of its iterations. In the Greek legend of the origin of the Werewolf we find an inextricable bond to the concept of the cannibal. As the Myth reads, there was a King named Lycaon. When King Lycaon invited Zeus to his city, Zeus used it as a spy mission and was all suspicious; Lycaon caught him and wanted to play a trick on him for revenge. Lycaon hid human flesh in the food of the party to try and get Zeus to lose his immortality by accidentally eating it. But Zeus was far too savvy for this and instead punished Lycaon by making him part wolf who would crave to consume his own kind.

There is an historical aspect of the Werewolf that could explain some of its legends to be found in the Northern countries. There was a special

kind of warrior in Norse legends and Viking tales that would take on the magical powers of the wolf and use them in battle. Most are familiar with the Berserker, the version of this warrior that used the Bear to suit this purpose, but there were also many who took on the form of a wolf. Hailing from the cult of Odin, they were called the "Ulfhednar" and they dressed themselves in the skins of wolves so that they appeared to be half man, half beast. In Europe, one of the most famous real-life werewolf stories, that of Peter Stubbe, involves wearing a wolf skin as well. Peter Stubbe, according to the tale, wore a belt made of Wolf skin and claimed that was what gave him supernatural powers and the ability to shapeshift in a similar fashion as the Ulfhednar. In one of the Norse sagas called the Vatnsdaela, the warriors wore wolf skins like a kind of armor and as a result were immune to any battle wounds and could withstand even sword blows without incurring injury. Wearing the skin of an animal for this purpose can also be seen in the warrior legends of Hercules who dons the skin of the Lion he conquers, making him immune to attacks. Some connect these Wolf Warriors to the two wolves that were Odin's pets, called Geri and Freki. One scholar, named Michael Spiedel, affiliated these two beasts specifically with the Wolf Warriors. One of these wolves especially plays a very important role in the epics of the apocalyptic battles of Ragnarok: Odin's wolf Freki is conflated with the famous beast wolf Fenrir.

There is a certain type of wolf that is spoken about in Norse mythology, different than a regular wolf. It is a kind of supernatural evil wolf, and it is called a Warg. The scariest thing about this type of wolf is that it is not restricted to the forests and mountains of the wild, but lives latent and waiting in horrible potential within the hearts of us all. Sometimes written as "Varg" or "Wargaz," this word is usually translated as destroy or consume and is a word synonymous with destruction. The word Warg came into popular awareness through the story of Beowulf in which these evil creatures were known as the Moor walkers who restlessly run through the swamps seeking to eat anything that comes into their path. They are the bottom dwellers and live in dark misery.

The name Warg was used to describe a specific Wolf in the Norse apocalypse sagas of Ragnarok, whose name was Fenrir or Fenris. There are theories that Fenrir was the original werewolf story, depicting the uncontrollable animal nature concealed deep within humanity.

Essentially, Fenrir's tale goes as follows: The wolf Fenrir is chaos and destruction embodied, and he begins to grow to a humongous gigantic size, feeding on its own power. The wantonly explosive and defensive emotional nature of Fenrir surpasses all boundaries and limits that any rational being would respect. Something must be done about it so the Gods get a magical fairy golden rope made in order to bind Fenrir from doing any more harm, and place him in bondage much like a prison. Here the wolf is subdued and imprisoned in order to keep his chaotic nature from wrecking everything. Even bound in this way though, the Gods realize the wolf is still a living creature and does not deserve to be put to death simply for being what it is, yet no one is willing to feed or care for the wolf and the Gods leave it to suffer in its dungeon of torture. Some of the Gods even took pleasure to see Fenrir all tied up because they felt like he deserved to be punished for all that he had done. They laughed at Fenrir and humiliated him and felt quite righteous at his suffering. This moment in the saga is where we learn the lesson of Hubris. Here hubris (or selfish pride that disregards another) has a triple meaning; it is etymologically related to destruction and wanton violence (Fenrir), but it also is used by the Ancient Greeks to mean pleasure taken in the suffering and humiliation of another's punishment (the Gods' attitude to Fenrir). The third being that of pride in oneself at the expense of another as a selfish act that disrepects life (both Fenrir and the Gods).

Finally the warrior Tyr comes to feed the wolf and put it out of its hungry misery. Tyr offers up his own hand to feed the wolf that it may not starve, but at the same time be kept bound in the rope. This compromise is the only thing that keeps the balance of energies in the cosmos intact according to the story and prevents the world from falling apart,

essentially relating the concept that treating evil in an evil fashion is still evil and justice need not be cruel.

Many have interpreted this story as stressing the importance of unmet needs and how they can animalize humans, and how they must be controlled but cared for, neither too much or too little. This maintains a healthy balance in our lives with the light and darkness within ourselves, paying attention to the shadow, and giving our bodies what they need, thus preventing us from turning into wolves as a result of our ignored animal natures that go unfed.

One of my personal favorite versions of the tale of the Werewolf that mirrors the Fenrir saga comes from the Hebrew tradition of the Hassidic Jews. There is a werewolf story told through the Baal Shem Tov, the creator of the Chassidic teachings and viewed by some to be a messianic figure. The werewolf story of the Baal Shem Tov is really about transforming emotional pain. In the fable, there is a werewolf that is a woodsman by day who turns into a hideous cannibalistic werewolf when the moon is full. All the school children are terrified of him. No one will go near the forest anymore and they all hide in their houses frozen with fear. All the children, that is, except for the Baal Shem. The Baal Shem Tov holds to faith and courage and goes straight for the beast to seek him out on purpose in a fearless, willful manner. The Baal Shem Tov sings very loudly and suggests to all the children that they must just keep singing to quell their fear. Finally, he confronts the Werewolf on the full moon and enters right into the werewolf's heart through his song. He sees it twisted, black and distorted with pain. He merges with the heart of the beast, and in this moment of becoming one with his enemy through sympathy, the Baal Shem Tov comes to understand the reason behind its wanton destructive nature. He loves the beast in this moment of compassion and rises out of his fear to heal the heart of the creature by nourishing it with love. This version of the story reads like Fenrir's tale as it personifies chaos and destruction in the werewolf and how it is bound and overcome through

sacrifice of the self. A domestication of our repressed animal nature by feeding it as you would a wild beast.

Some interpret this submergence of our animal self in the form of the Werewolf as more of a psychological representation of our sexuality. There has always been a link to sexuality in the idea of the evil wolf. Even dating back to Roman times, the wolf was affiliated with Libido. The word "Lupa," from which we get Lupus, was the name for a whore on the streets of Rome. Although the name had been used at its source originally for the Mother of Rome itself, the she-wolf who raised Romulus and Remus, it became slang for a loose woman. Lupa translated to "She-wolf" and represented a wolf who was so fertile and mother-like she could even care for the young outside her own species. There was a Festival in Ancient Rome called "Lupercalia" that celebrated her; it fell on St. Valentine's day and involved fertility rituals. Later in Europe the wolf became attached to the prowess of the male Libido and has remained persistent as a symbol for it.

The symbol of the moon with the werewolf likely represents man's shifting and animalistic emotional and physical nature. In most ancient societies, the moon is affiliated with our emotional shadow and its periodic release.

> "The realm of the perishable begins with the moon and goes downwards...there is no doubt the moon is the author and contrivor of mortal bodies." —Macrobius

A good example of this can be seen in the Tarot decks of old where the card representing the moon contains both a wolf and a domestic dog underneath the full moon with a creature crawling out of the depths of the ocean. Much like the Werewolf, here is representing our two sides, civilized and wild, and how these shift back and forth cyclically and both require our acknowledgment, attention and feeding.

Our deep animal urges to destroy, attack and consume are just as real as humanity's compassionate giving nature and we have to deal with them both, not just in ourselves but in others. The werewolf is the human who loses control of their emotional nature. Their nature becomes dominating and possesses their bodies and minds, causing them to consume the flesh of others in order to feed their base appetites.

There must be placed limitations and boundaries on violent hubris lest it become wanton and possess the body.

The moral of the story of Fenrir is the untamed dark animal nature of humans that can be managed through discipline. If it is left unchecked and unfed it will rage out of control, so don't forget to feed your beast!

"Those who do not seek release from the bondage of the instinctive drives by the road of inner development remain the slaves of their own passionate desirousness or suffer the sterility resulting from its ruthless repression. In any time of crisis these persons have no power to curb their own barbaric reactions."
—M.E. Harding, *PSYCHIC ENERGY*

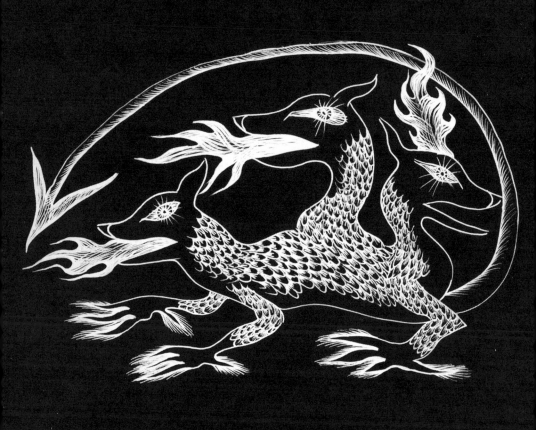

CERBERUS

"Kerberos the arg
and all the wargs
who follow him."
—Heinrich von Veldeke, *ENEIDE*

Canine companions who contribute to the mythological creatures can be found in the stories of Cerberus and the Hell Hounds. The Cerberus tale is of a three-headed dog and a woman of the underworld. Cerberus guards the gateway to the underworld, which his female Goddess companion oversees. Cerberus is a creature that is intimately connected with the symbolism of the triple Goddess who descends into the Earth, known by many names—Isis, Hekate, Cybele, and Demeter to name a few. These two, the Goddess and her dog, are so inseparable that they might be considered as the same creature as Carl Jung notes, certainly at least in the case of Hekate's story. Cerberus could be Hekate's werewolf form since she has the properties of a shapeshifter and is often depicted with three heads herself, one of those being a dog. Hekate is also ruled by the moon, echoing the symbolic werewolf tale.

"Hekate with three heads and six hands, holding torches in her hands, on the right side of her face having the head of a cow; and on the left side the head of a dog; and in the middle the head of a maiden, with sandals bound on her feet."—*GREEK MAGICAL PAPYRUS*

There are several theories as to the meaning of the name Kerberos, first called by Hesiod. Some say it means "dark demon," but it is also interpreted as "spotted." When split down its center into Keras and

131

Barus, it means "powerful horn." Other etymologies place it closer to a Norse word for "growl," which is also the meaning of the name of the Norse Hellhound, Garm. In Norse mythology there is a nearly identical version of the story of the Greeks. The Underworld Goddess in the North is called Hel, who is a giant. Fenrir the Wolf is her brother, but she also has her own hellhound, like Cerberus, named Garm. Garm guards the entrance to the underworld. There are many versions of this archetype, the underworld psychopomp and its Hellhound, all over the world. Even the Shamans of Mongolia have their version of the hounds who guard the underworld, known as Chardas and Botos. Isis and Anubis form this pair in the Egyptian version of the story. Anubis was a Chthonic God in the Egyptian Pantheon, and acted as a Psychopomp for the dead through their journey in the land of the afterlife. He had the head of a Jackal. He assisted Isis in the underworld undertakings of the transformation of the God Osiris. In nearly all the versions of this tale it is consistent that there is an underworld, Hell, or land of the dead and a dog who guards and assists it.

There is the land of the living and the land of the dead, then there is the boundary between the two and that boundary is Cerberus; he keeps the dead from coming back to the land of the living and makes a clear distinction between them. In this sense, Cerberus is a boundary guardian, kind of like the Sphinx and the Griffin. There was an actual Gate to Hell discovered archeologically that had a very real Cerberus Guardian overseeing its entryway. Sometimes called the Ploutonion, this portal was discovered in the ancient Phrygian city of Hierapolis. Scientists found it was a true gate to death as the crevice that opened into the Earth was emitting a deadly gas that would cause all who entered this doomed door to meet an untimely end. There were two guardians on either side of this real-life underworld, Cerberus on one side and a coiled serpent on the other.

Viewed through the symbolic lens, the boundary thought to be guarded by Cerberus is the one separating the conscious and unconscious

mind. The underworld Gods and Goddesses are what are called "Chthonic," which is usually translated to mean beneath the Earth, or of the Earth. As representatives of the unknown and dark territory of the restless animal mind that dwells beneath our surface, these archetypes assist us in navigating the uncharted waters of our own primitive lack of awareness. Taken in this context, a confrontation with Cerberus occurs when we enter into the subconscious realms. Once we cross over this threshold, there is no going back and the contents of our lower mind can not be unseen, they can only be accepted as they have a deep purpose and meaning. In a more psychological sense then, Cerberus is a very real thing that many people experience within themselves when they meet their hidden demons:

"In Hebrew Dog is pronounced Keleb and carries the root kol, 'totality.' Reversing two letters, we have Kebel meaning 'link,' or 'chain.' The dog Cerberus, or Satan, chains man, who has chosen him for master to his 'non-becoming light' (has thus become evil) to this single pole of the tree of duality is symbolized by the darkness of the underworld. With Cerberus man experiences the enemy, the adversary to his pole of light. Everything points to this being the character we encountered with Job, 'the adversary of'. But no one can 'embrace his satan' unless he has expelled from himself the cohort of demons whose name is 'Legion.' They are parasites of creation and 'devour the flesh'."
—Annick de Souzenelle, *THE BODY AND ITS SYMBOLISM*

Within our Minds, the role of Cerberus, Anubis and other Psychopomps is to guide us through the experience of having an enemy that can kill us (death being the unstoppable enemy of all) and how to

navigate that experience in the deepest parts of ourselves. Dealing with Danger and death in terrible forms is the polarity we must raise into our conscious awareness that typically wants to only enjoy the pleasureable aspects of the Earth Goddess' fruits. Cerberus reminds us to take heed, know and enter the dark world of death we prefer to avoid. The underworld really is literally the Earth itself, specifically her soil, within which everything grows and dies. To expand upon the understanding of what Cerberus is guarding, his Hekate, his Magna Mater the Earth herself, we can examine some of the material on the undertaker Earth Godesses of the dead who sometimes take the form of another Mythological Beast known as the Vampire.

VAMPIRE

"Anyway, after drinking all of Raktabeeja's blood, Kali starts eating the other slain demons and goes into a blood-crazy dance of death"

—Reed Wheelock,
A DISCUSSION OF HINDU MYTHS

While investigating my own middle name, I became intimate with a lesser known kind of Vampire, the ancient female Goddess blood drinker. My middle name is "Dakini," a Tibetan word for a kind of spirit. My mother came across it when she was living in Tibet in her hippie days. My mom said a Dakini was like a fairy, or spirit in Tibetan Buddhism, but I was to find out much more about this creature as I consumed the literature regarding the tantric entity. The name Dakini means "Sky walker," one who can fly through the sky or outer space. They are shown in several different forms, but the ones I always saw pictures of were bright scarlet red. The Dakini was always holding up the top of a skull which was turned over into a bowl and she was drinking blood from it. My tender young mind thought that seemed pretty Vampire-style. She often had sharp teeth, and there was a Queen of the Dakinis called the Vajrayogini who drank her own menstrual blood and was vermilion red in color. The Dakinis inhabited the burial grounds and were said to also eat corpses after cremation. The Dakini was my first introduction to the idea that there could be female vampires in Ancient cultures.

Most envision the Vampire as some sexy charming man who mesmerizes women into his Harem and turns into a bat, thanks to Bram Stoker's *Dracula*. This is certainly not the most interesting Vampire story if we look back through time; historically there were

many female Vampires in folk tales of cultures around the world who were far more terrifying than Dracula.

The lost feminine aspect of the Vampire can be found in the origins of the word itself. When traced back through its etymology, Vampire translates from a Turkish word for "Witch." Though this lineage is somewhat disputed among scholars, it remains one of the origin points and it is difficult to ignore the specifically ladylike inference. The foundations of the word "Witch" include among them Necromancer, so there is connection between the identities of the witch and the Vampire, namely death, drinking blood and menstruation.

Dakinis are flesh eaters of corpses at the cemetery and drinkers of Menstrual blood. Many of the older tales we have of Female Vampires place them at the burial grounds, or tombs and have specific references to the undead as these Chthonic women form an intimate relationship with all aspects of death. Another example of the cemetery ladies can be found in the Valkyries. Valkyries are female warriors who fly down from the sky to collect the corpses on the battlefield. You might not think of classifying them as Vampires, but it is strange that one of the meanings of the word Valkyrie is "Taste." Some say they "Choose" (one interpretation of Valkyrie's meaning) the corpses from the carnage, but another word used is "taste." Some scholars make note that the Valkyries ate the dead warrior's corpses, making them a bit more like the Dakini in that respect. There are also the Ghouls, Estrie and the Mare who are female death-dwellers that either eat the dead or drink their blood, all being female and all haunting the graves of those who passed. These three can be found scattered through Europe, including Jewish traditions. The queen of the ghouls in Judaism is named Alukah, the bloodsucker, known as Aluk to the Arabs and thought to be a ruler of the underworld.

After finding references to all these different kinds of blood-drinking girls in ancient religious descriptions, I focused a bit on the blood-drinking itself, since that is what makes a Vampire unique

in terms of distinguishing it from other regular cannibals. In most religions, drinking or eating blood, even the blood of animals, is a terrible taboo and not permitted. In ancient India, blood was unclean and polluted with the soul of another and if you consumed it you contaminated yourself with their soul. In Judaism it is strictly prohibited for this reason also, because it damages your soul. Blood is certainly a forbidden fruit not to be consumed, lest you turn into a monster.

"Blood, and the Retribution against the Giants. The conception of blood in priestly law and the flood story is important for understanding the crimes of the giants in the Book of the Watchers and other Enochic texts. The consumption of blood is prohibited in Genesis 9. The universal importance of the ban on blood consumption is highlighted by its inclusion in the covenant given to Noah. It is, literally, the first law promulgated in the Hebrew Bible...Gabriel is to foment a 'war of destruction' among the giants...in Genesis this prohibition is associated with retribution for murder, an unlawful spilling of human blood. The one who sheds human blood will have his own blood shed because people were created in the image of God (Genesis 9:6)...Blood, so understood, has a mythological power or force—it contains divine potency and its shedding constitutes a transgression not just against the victim but against God, who endowed him with life by giving him a soul."
—Matthew Goff, *MONSTROUS APPETITES: GIANTS, CANNIBALISM, AND INSATIABLE EATING IN ENOCHIC LITERATURE*

Blood drinking was so bad, there began to be circulated an idea of a "Blood Curse" that if you participated in this action, you would be doomed to repeat it, and that could be at the base of the legend that if you are bitten by a Vampire, you then become a vampire. The Blood curse was made popular by Cain and Abel: it implied that if you spill blood on the earth, your blood will be spilled on the earth.

"It will have blood, they say. Blood will have blood.
Stones have been known to move, and trees to speak.
Augurs and understood relations have
By magot pies and choughs and rooks brought forth
The secret'st man of blood—What is the night?"
—*MACBETH*

The Greeks and Romans have the Lamia or Lemure as examples of this reciprocal horrible repeating cycle of a blood curse. Lamia or Lemure was one of Zeus' lovers and when Hera, Zeus' wife, found out about the affair she went insane with rage and ate all of Lamia's children. It is said in the legends that because Lamia's children were eaten by Hera, and she watched this event, that Lamia is doomed to repeat this action and she begins to eat the children of others and drink their blood compulsively.

One of the more primordial Vampire Goddess mothers whose blood drinking takes from the young is named Lilith.

Lilith comes from the traditions of the Hebrews and is still acknowledged in modern-day Judaism practices and very famous in popular culture. Known as the original female half of the primitive human Adam Kadmon, she is a figure who comes in at night in the darkness to drink the blood of babies laying in their beds asleep. "Let not Lilith enter here" is a sign that still hangs above the cradles of many in the Jewish faith, and some say she is the same as the Lamia and Lemure, all mothers doomed to repeat the drinking of blood of their young due to the blood curse.

Stories of the Blood drinkers often have an addendum that this activity will snowball into an unstoppable craving that never ends and spreads to others. Native Americans talk about the Wendigo who becomes obsessed with eating others and drinking their blood—once they begin they can't stop. The Vampire curse then seems karmic, tied to the action of Bloodletting that would appear to be a universal law of reciprocity if we believe the stories.

An early and possibly prototypical version of this tale comes to us from the Earth Goddess herself. A potent telling of it arrives via the Indian folk traditions of Kali. Although typically not considered an Earth Goddess, she is indeed the black Earth mother, who is the creator and destroyer of the world. She rides a fine line of Blood drinking being both good and evil in her role of retribution for the Cannibal Giants.

"Kali 'the black' is often called Kali Ma the black mother. Her great achievement is slaying, with the aid of Chandi, Raktivija, the principal leader of the Giant's army. Seeing his men fall, he attacked the Goddess in person, when for every drop of blood that fell from his body a thousand giants equal to himself arose. At this crisis another form of the Goddess, named Chandi, came to the rescue. As Kali drank the Giant's blood and prevented the formation of new giants, Chandi slew the monster herself."—John Murdoch, *PAPERS ON GREAT INDIAN QUESTIONS OF THE DAY*

When we read the story of Kali, we find that she has to drink the blood of those who drink blood in order to stop the blood drinking, but then she can't stop drinking blood even after she wins. The Goddess gets all tangled up in this blood curse business. The way the Saga unfolds, Kali is called upon to defeat the king of the Giants who is eating everyone

and drinking their blood. But each time Kali tries to kill him, his blood spills upon the Earth and a bunch more of him grow from the blood drops. Kali decides to eat the blood to prevent this propagation from occurring. It works and she kills and eats every last scrap of him, but then she goes blood-crazy and starts wanting to drink the blood of everything, spiraling out in a grotesque blood frenzy.

In this epic battle against the huge cannibalistic Giants, it is Kali's willingness to drink the blood of the blood drinker that is responsible for saving the day, so here blood drinking became a good thing although it possessed her.

Several cultures talk about feeding the Earth with blood in order to grow things. This becomes the archetypal harvest sacrifice myth that many argue forms the origin of the Jesus story and can be seen in all the Grain God myths such as Osiris, Dionysus, Demeter and many more. There are old Gods related to the Earth and the Harvest of her fruits that all involved blood being offered into the Earth.

"Cihuacoatl, 'serpent woman' was an aspect of Earth mother, in H.B. Nicholson's fine phrase 'the great womb and tomb of all life'... The original and essential act which created the Earth and made it fruitful was not sexual. The two sky gods are said to have seized the limbs of the great earth monster as she swam in the primeval waters and wrenched her body in half, one part forming the sky the other the Earth... but the monster wailed for food, refusing to bring forth until she was saturated and satiated with blood and human hearts. Only then did she yield the fruits which provided men's sustenance. This was the great Earth lady" —Inga Clendinnen,

AZTECS

In some versions of the stories it seems the Earth was the original Vampire, hungry for the blood of her human children. The Mother Earth in these versions must drink the blood of the humans in order to be happy. This forms the basis of the human sacrifice cults who would spill the blood of the victim for the Earth's cooperation with the crops, much as depicted in the popular film, *The Wicker Man*. This type of Earth spirit, the vengeful, angry or wrathful one, needed to drink blood and she wanted it spilled upon the Earth. If there was some kind of primordial curse for humans pouring blood on the earth, maybe it is the Earth who will take their blood from them.

The Goddess Vampire mother Earth will drink the blood of us all deep within the folds of her soil one dark night or another, after all. According to the oldest legends about the Earth around the world, she wants to drink our blood in order to bear us fruit and harvest.

These old ways of Blood sacrifice to the Earth were reputedly challenged by Jesus, who symbolically at least was meant to put an end to such practices and stop the blood rituals altogether through his willingness to shed his blood to the Earth in a sacrificial action. Blood drinking is defined as having terrible spiritual repercussions far and wide. Paradoxically, simultaneously, the drinking of the blood of a specific person, namely Jesus Christ, offers the promise of immortal life and is one of the most popular ideas on the planet participated in on a weekly basis. Somehow the Christian traditions claim that since Christ offered his blood for his disciples to drink in the Eucharist it was not only okay, it was super good for you and would make you live forever. It is understandable that Jewish folks might disagree with this practice after all the stories of bloodthirsty Giants and Noah's trouble to get rid of all the blood drinkers. In Santeria cultures of Africa you were not permitted to drink the blood because it was for the Gods, and if you took the blood you were stealing from them. Earth cults were no different; the blood belonged to Mother Earth and no one else was allowed to take any blood for themselves.

There have been many Earth Goddess cults that make blood sacrifices, and even Human sacrfices for the purposes of appeasing her. Kali cults known as the Thugees were rumored to kill people just to feed their blood to her.

This seems to be a misunderstanding to me, however, for the action of taking the blood for yourself to give to the goddess through the action of killing is hubris at its finest. That blood is not yours to take and to offer the Goddess something you stole from her seems a bit insulting, at least to me, so perhaps these cults were misinterpreting the meaning of why the Goddess gets our blood, which brings us back to the idea of sacrifice and blood drinking.

There are older ideas of blood drinking being spiritually nourishing other than the Eucharist. All of the ideas of blood drinking being life-affirming and beneficial have a condition: they are all only nourishing if the blood is offered freely in sacrifice of the self by whomever the blood belongs to. One of my favorite examples of these is Chinnamasta, an Indian deity who drinks her own blood and shares it with others. When Chinnamasta engages in blood drinking it is seen as receiving food from the heart rather than an abomination. According to the legend, Chinnamasta was at the river bathing with two friends, when suddenly they became very hungry. In response to their hunger, Chinnamasta cuts off her own head and offers them her blood to drink, while also engaging in drinking it herself. This type of Blood drinking is more akin to the Phoenix who pierces its own breast to feed its children—it is given, not taken. Much like Jesus willingly gives his blood as food in the Last Supper, we see how magical drinking blood can be when we don't try to take it for ourselves, but wait until it is offered. The Blood Curse does not seem to infect the individuals who give of their blood for another, only those who take the blood of another.

It could be that the great Mother Earth Vampire is offering us her body, much like Jesus, Chinnamasta and the Phoenix, for us to consume in the

form of all the food that she gives us to eat, but that she needs to eat too. This brings us to the last connector of the Earth Chthonic Goddesses and the vampires, the Menstrual blood. The older cults, before the human sacrifices started, are referred to as goddess cults because they had one thing in common, offering their menstrual blood to the Earth. It stands to reason that the Earth can be fed lots of blood from her children without anyone having to die in this fashion. Mention of Menstrual blood being drunk and offered to the Earth is made in traditions spanning far and wide but was discontinued as the worship of the Goddess fell out of favor. References to menstrual blood being offered in this fashion include the Eleusinian mysteries, many Isis rituals, and extend into the Cults of Hera, Cybele, Demeter and others. In the cults of Hera, this action was rumored to have been engaged in and the Menstrual blood was called "the wine of Hera." Ancient cults of Isis called this practice the "Sa," where menstrual blood was both drunk by the participants and offered to the Earth.

The cut-and-dried judgment that drinking blood is a terrible thing seems to not be so black and white. In some cases, it can save the world from demons, or turn you into an immortal savior. For the Earth Vampire, the drinking of blood is an unending cycle of life created and destroyed upon her fertile dirt.

MANTICORE

"His horror is increased on seeing the Mantichor, a gigantic red lion with a human figure and three rows of teeth: The silky texture of my scarlet hair mingles with the yellowness of the sands. I breathe through my nostrils the terror of solitudes. I spit forth the plague. I devour armies when they venture into the desert. My nails are twisted like gimlets; my teeth are cut like a saw; and my hair, wriggled out of shape, bristles with darts which I scatter, right and left behind me, Hold! Hold!"

—Gustave Flaubert,
THE TEMPTATION OF ST. ANTHONY

The mysterious Manticore is an obscure mythological beast with much confusion surrounding its true nature. Tales of the Manticore roam all over Persia, Greece and India. Most are familiar with its Lion-bodied form with a human head and it is most famous for its consuming reputation. The name Manticore is traced back to Persia and is translated as "man-eater," originating from the root "mer" which means to die, and Kvar, to be swallowed or eaten. Perhaps the human head upon this beast was meant to infer that this particular Lion had taken to eating Humans as its preferred meal. Lions literally can and do eat people, with some individuals of this species becoming

focused on eating people on purpose as was exhibited in the famous case of the Tsavo Lions of Kenya who reportedly ate around thirty-five people. Of the several species that seem to target human beings for their meals, which have been shown to mainly be lions, tigers, leopards and crocodiles, this number isn't even the highest recorded. There was a single Leopard in India credited with killing and eating two hundred humans. This could feed the possibility that the Manticore was simply a man-eating beast.

The Manticore is usually depicted with a human face, a lion's body and a scorpion tail. It can shoot out projectiles from its tail like a porcupine and goes around eating people. Creepily enough, according to some accounts, it can also talk like a person:

"The mantichora has the face and ears of a human being, grey eyes, a triple row of teeth...a lion's body of a blood-red color, and a voice like a pan-pipe blended with a trumpet. It stings with its tail like a scorpion. It is very fast and has a special appetite for human flesh... And among all beasts of the earth is none found more cruel, nor more wonderly shape, as Avicenna saith. And this beast is called Baricos in Greek."
—Bartholomew Anglicus, *MEDIAEVAL LORE FROM BARTHOLOMEW ANGLICUS*

This is one of the most famous descriptions of the Manticore, but in my research, I came across a more obscure reference to its identity. The story of this creature shown to me was in a battle between Satan and God in the Book of Revelation. In Revelation 9-12, there is a surprising passage on these man-eaters, and presents them with a very specific role that they play in the apocalypse. In Revelation, the word used to describe them is "Locust," but the specific Hebrew word used is cal'am, "to swallow down," "to consume" which is essentially the

same meaning as Manticore described above. If we look in the Book of Revelation, the locusts are described thusly:

> "And the shapes of the locusts were like unto horses prepared unto battle; and on their heads were as it were crowns like gold, and their faces were as the faces of men. And they had hair as the hair of women, and their teeth were as the teeth of lions. And they had breastplates, as it were breastplates of iron; and the sound of their wings was as the sound of chariots of many horses running to battle. And they had tails like unto scorpions, and there were stings in their tails: and their power was to hurt men."

Some of the artistic representations of these creatures in Christianity throughout the ages show them like sphinxes wearing crowns and having wings. They have the bodies of Lions, the faces of humans and scorpion tails, just like the Manticores, but are called locusts. They are always shown crawling up out of the Earth in true Chthonic fashion. The place they are crawling out of is the Abyss, as they were cast down into it with their king. The King of the locusts, or Manticores, is none other than the god of the Abyss, Abaddon. Abaddon is the leader of the Destroyers of the Earth, known as the Locusts/Manticores. It is the Locusts that play a key role in devouring the hearts of mankind with evil during the end times.

> "The star opened the pit of the abyss, and smoke rose out of it like the smoke of a great furnace, and the sun and the air were darkened by the smoke from the pit. And out of the smoke, locusts descended on the earth, and they were given power like that of the

scorpions of the earth. They were told not to harm the grass of the earth or any plant or tree, but only those who did not have the seal of God on their foreheads."

—*REVELATION 9:2-4*

The Manticore depicted in this state seems to form a counterpart to God's entourage of creatures known as the Cherubim. Cherubim are four-faced creatures that incorporate lions as well, but these oppose the Manticores during the battle. It is almost as if there are two teams: a team for the Creator God and a team for the Destroyer God. But then it gets more complicated, because those two things are actually the same thing fighting against itself. The creator and destroyer Gods merge into one being at the grand finale of the story, making the whole thing seem like more of an Ouroboros. The Dragon that destroys the Dragon.

I came across an old *National Geographic* magazine that mentioned a bunch of Muslim lore regarding the Locusts from the Quran. Here the Locusts are not the Army of the Destroyer, Abaddon, but belong to God itself. In many places in the Middle East the Locusts are called God's Army, or "Jaish Allah," and it says the Hebrews called them by the same name of God's army in Joel 2:

"I will repay you for the years that the cutting locust, the swarming locust, the hopping locust, and the devouring locust have eaten — my great army, which I sent against you."

—*JOEL 2:25*

It sounds pretty weird, but "Lord of the locusts" is a title of God, at least in some traditions. In Islam, it is thought that a law was written by Mohammed regarding the Locusts of Revelation. It said that you couldn't kill the locusts because they were the army of the most high,

meaning God. It says that Allah himself is the "Lord of the Locusts" making creator and destroyer equal contenders. It goes on to state that the locusts were made from the same clay as Adam, the first man, giving them some kind of relationship to humans, perhaps why they are shown with a human face? Or at least indicating they are not evil, but part of God even though they are highly destructive. There is also an element of a crown worn in the Book of Revelation by the Manticores called a crown of glory. The Manticores keep their crowns of glory on their heads while they torture humans as opposed to the heavenly creatures, the Cherubim, who throw their crowns down at their feet in humility showing that the righteous crown-wearing Manticores are only full of pride. Interestingly, there is a clear distinction and restriction on these biblical Manticores, unlike those found in, say, India: they are forbidden by God to actually eat and kill humans, instead they can only inflict pain upon them and torture them.

In Manly P. Hall's *Secret Teachings of All Ages*, he states that the Locusts symbolize the passionate emotions of humans that "destroy all that is good in the soul of man, and leave a barren desert behind them." So maybe it is just aspects of ourselves undergoing an internal emotional battle; the Manticore then would be the struggles that consume us and eat us away from the inside out like a swarm of Locusts.

The Arabs have a fascinating physical description of the Locust:

> "The Locust has the form of ten of the giants of the animal world, weak as he is—face of a mare, eyes of an elephant, neck of a bull, horns of a hart, chest of a lion, stomach of a scorpion, wings of an eagle, thighs of a camel, legs of an ostrich, and tail of a serpent."
> — John Whiting, *"Jerusalem's Locust Plague," THE NATIONAL GEOGRAPHIC MAGAZINE, VOLUME 28*

This description of real locusts was written in such a way as to make me think the Manticore could actually be a literal insect locust, and someone just described the bug itself as looking like it had all of those different features. Perhaps through time someone actually drew the description as an animal instead of realizing it was just being used to describe an insect with the parts of other animals to describe its attributes. Perhaps the man-eating consumers in Revelation were a plague of Locusts that somehow came to be shown as a Manticore/Sphinx type of beast due to fantastical and poetic license used to illustrate their nature.

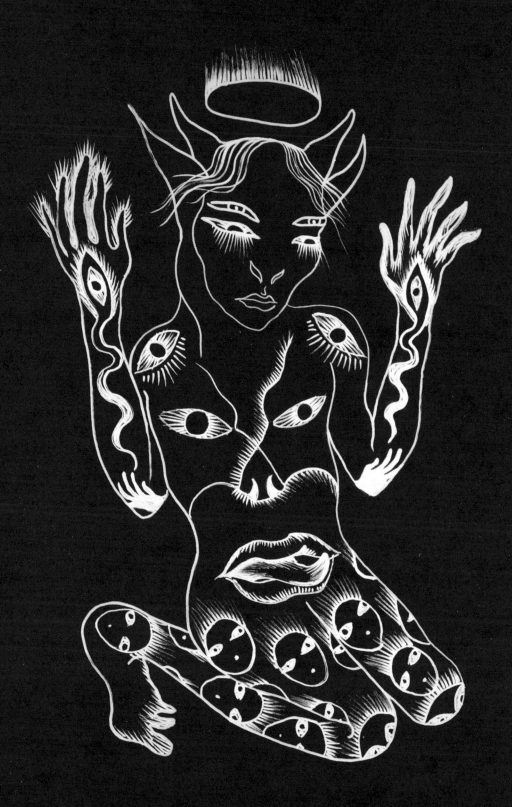

THE BEAST OF THE APOCALYPSE

THE SECOND COMING

Turning and turning in the widening gyre
The falcon cannot hear the falconer
Things fall apart; the centre cannot hold;
Mere anarchy is loosed upon the world,
The blood-dimmed tide is loosed, and everywhere
The ceremony of innocence is drowned;
The best lack all conviction, while the worst
Are full of passionate intensity.
Surely some revelation is at hand;
Surely the Second Coming is at hand.
The Second Coming! Hardly are those words out
When a vast image out of Spiritus Mundi
Troubles my sight: a waste of desert sand;
A shape with lion body and the head of a man,
A gaze blank and pitiless as the sun,
Is moving its slow thighs, while all about it
Wind shadows of the indignant desert birds.
The darkness drops again but now I know
That twenty centuries of stony sleep

> Were vexed to nightmare by a rocking cradle,
> And what rough beast, its hour come round at last,
> Slouches towards Bethlehem to be born?
> —William Butler Yeats

The King of all Beasts in the minds of those who inhabit the Christian West is the Beast of the Apocalypse. It could be the most feared entity in all of Christendom other than Satan. It is the ultimate boogeyman and amalgamation of all the evil that is Natural and bestial. Aside from Western traditional concepts from the Book of Revelation, there are many cultures who also have some version of an epic gigantic beast that humanity will need to face at some climactic world-ending time.

The Apocalypse monsters usually have an affiliation with Chaos. They are essentially a threat to order, logic, reason and the rational mind. They are also usually enormous. There is a gigantic quality to them and a notion that they can't be defeated by a regular person. It will take some kind of super extraordinary person to do the job. That person is the Messiah, or world savior. The role of the world savior is to fight this humongous Beast and save us all from its chaotic consequences. The Apocalypse Beasts also all tend to emerge from something below, either from deep within the bowels of the Earth, or as a Kraken rising from the Abyss of the sea. If one were to imagine the collective consciousness of Humanity, the Beast of the apocalypse would be an animal that rears up as a result of not just one individual's inability to keep their mind from chaotic leanings, but a kind of mass hysteria leading many to fall into doubt and fear. The consequence of a humanity bent on destructive fearful thoughts and actions is always followed by the emergence of an über Beast in response to our own minds in the tales of the ancients. The stories of these monsters tell us that some creature could come out of the depths to eat us all because our brains had gone south and attracted the thing right to us. Just as a calm and peaceful mind can attract a Unicorn, a

mind in the throes of chaos can magnetize to the Beast of the Apocalypse. This happens not because we make this beast, but because the Apocalypse Beast is always there, waiting to be summoned through the mirror we are making of its energetic signature in true Archetype form.

"In view of the romanticists, the creation of a myth was not due to an intentional act of an inspired individual, but was the natural and unintentional activity of the collective mind...symbol and myth are not intended to give, in a veiled manner, information about something known otherwise, but they reveal the innermost nature of a people, they do not copy reality, they are responses to reality."
—Alexander Altmann, *SYMBOL AND MYTH*

Many have compared the rising of the Beast of the apocalypse to the Titans being released from their imprisonment in the underworld. According to the story, the Titans were defeated by the new gods and then bound in chains to be secured underneath the Earth. Then some event occurs and the Titans are released from their dwelling and bring chaos and terror to the world again only to be dispatched by the main hero or messiah archetype. The Norse version of this is Ragnarok where Fenrir is released from the chains that bind him and wreaks havoc on the Earth while the serpent of Asgard eats everything.

The symbolism of the Chthonic monsters being released from the bowels of their dark dwelling is indicative of humanity becoming aware of all its deepest darkest subconscious secrets.

Our collective fears rise into the awareness of all in this moment and it will take someone who is able to connect both the minds of the conscious and subconscious awareness in their own being to be able

to defeat it through integration, not domination. The fact that the Apocalypse Beast is meant to be integrated into the human mind is symbolized in the story of the Behemoth and Leviathan. When these two end-time creatures creep up from the depths of land and sea during the Apocalypse, the Messiah defeats them and they then become food for everyone who survives. The bodies of the beasts that once devoured everyone become the food and nourishment of those who defeat them. The eating of the bodies of the Behemoth and Leviathan at the great victory party indicate that we must literally unify our flesh with their flesh, becoming one with them.

The Beast of the Apocalypse is the mother of all the Beasts, the Hydra, the Red Dragon, the primal source of all who creates all things from her flesh and blood. The Beasts really all belong to the dragon in that all things arise from the writhing mind of Leviathan. Tiamat is her name in the Sumerian epics and it is Tiamat the dragon that must be dealt with; all other beasts are just distractions. She is to be realized within the confines of individual awareness, and each individual must integrate her in order to utilize her primal powers for themselves. Once this is achieved they become the beast master, the dragon rider, the hero in charge of their own destiny. She is defeated by her own child who incorporates her instead of fearing the devouring and terrifying mother. We can unite with her and ride her to the ends of the Earth as Muad'dib rides the worms of Dune.

The Savior and hero of the oldest stories who bests the apocalyptic Beast within us is often a female. Inanna braves the underworld in the first heroic epic. It is Mary who is shown submitting the Red Dragon under the tread of her heel. It is the whore of Babylon who rides the back of the beast in her mastery. It is Kali who subdues the Giants. Mostly, it is women who save mankind from the terrible destruction of the animal mind. The Beast is so focused upon in these stories that the symbolism of the woman is often left unnoticed or disregarded.

"Where there is a monster, a beautiful maiden is not far away, for they have, as we know, a secret understanding so that the one is seldom found without the other."
—Carl Jung

The loss of the woman as hero counterpart leaves a gaping wound in the history and can be seen in the judgmental depiction of the whore of Babylon in the Book of Revelation. The symbolism that this Harlot is trying to communicate is that beauty soothes the savage beast. Beauty can be seen more like symmetry though if we are to get esoteric, thus the meaning of this old story is made clear: order is needed to defeat chaos. Plain and simple. The key to defeating the chaos that is brought about by the rising of the Beast is to make a pattern or symmetry, arranging delightful fashions so that we are not taken under by the confusion. But more importantly, since the divine mother monster is a female, only her own image can throw herself back upon her visage to be overcome. The woman is the mirror of the archetypal mother of all creation, due to her own ability to create, and in the end she will be needed to subdue the shadow form of the divine feminine that is Leviathan.

"Our conjecture that Eleazer had in mind the apocalyptic figure of the son of man is confirmed to the extent that there is an illustration of the 'fils de l'homme'...in unorthodox fashion, he is dressed like a woman, as is often the case with the hermaphroditic Mercurius in alchemical illustrations of the seventeenth and eighteenth centuries...interpreted as the creative and procreative power in the universe."
—Carl Jung, *MYSTERIUM CONIUNCTIONIS*

The idea of the dragon with the maiden exists at least as long ago as the ancient Hermetic material. It is Andromeda and the Kraken. In the

Hermetic story of the shepherd of Hermas, there relates an alchemical dragon of many colors (like a rainbow) that had a woman that appeared with it. Specifically, a woman wearing all white, a color worn to represent a virgin. We can see a version of this represented throughout Christian symbolism as the red dragon, or Beast of the apocalypse that is subdued by the power of the Virgin Mary. This is the meaning of Kuan Yin riding upon the back of the dragon, and it tells us that all women must independently come to terms with the forces of nature within themselves. This is not stated to leave Men out of the story, or mitigate the masculine in any way, but is stressed in relation to the biological reality of creation carried deep within the flesh of all females and how it connects them to the Mother of all living things that have been created, even if she is a Giant Monster. It is the divine feminine dark yin energy that is the Beast of the Apocalypse. It is defensive, destructive and rages out of control, the hidden Earth vampire who swallows us all. Only its counterpart, made in its image, the mother creatrix can know it, and through this knowing and understanding subdue it. The true power of the female nature is the revelation of the mother of all Beasts. She is creator and destroyer and lives closer to our surfaces than we may like to admit.

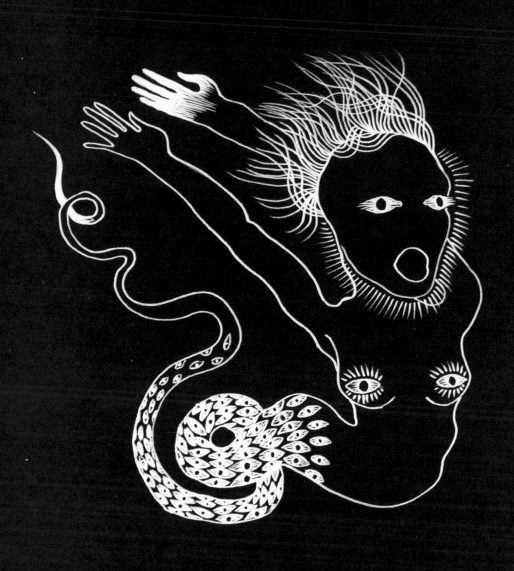

EPILOGUE

When the believer has mastered his lower self, so that it serves as a riding mount beneath him, the deeds of his heart will shine forth upon his face.

—Al-Jilani

The Beasts played with me as I laid them out upon these pages; throughout the course of writing this book I was visited by many superb synchronicities. As I sat down on the first day, my daughter chose to watch the new *Beauty and the Beast* movie, which stressed the need to hurry up and become human lest our beasts get the better of us and we become doomed to an angry existence ruled by our emotions. I took a break while writing the Werewolf chapter to go to the store and as I walked through the doors, I noticed that the song playing on the stereo system was "Howlin' at the Moon" by Boh Doran. The lyrics shouted at me: "When the darkness starts to fall, the writing's on the wall, and your skin crawls, while your heart stalls, then the Beast calls, and you're gone, Howlin' at the moon." It made me burst out laughing. As I was completing the work, my children began watching the new season of *Ultimate Beastmaster*.

As I made my way through each of the Beasts, recounting the lessons they held, I began to see the overarching lesson that all Beasts have to teach us: that of self-mastery and self-acceptance. This realization culminated in a Synchronistic divination message gifted to me via the kind agency of the Divination system called the I Ching. That day I received hexagram 38 which was explained as follows when I looked it up:

"When false energy enters and true energy recedes,
humanity is denied. Therefore the human mind
or lower self is symbolized by animals and demons.
With the mind of Tao buried away and the human
mentality taking charge of affairs, the influence of
habit becomes one's nature, and doubts and
ruminations come forth by the hundreds; this is being
like a pig covered with mire, a wagon full of devils."
—Liu Yiming, *THE TAOIST I CHING, Hexagram 38*

There are different aspects of human nature and some of those are animal. The Taoists have a deep spiritual lesson that humans must learn from the Beasts. They say that a human is like a horse cart. There is the chariot, a Beast and a driver. Under ideal conditions, the cart is directed by the driver, but when danger enters, the Beast drives as its fears take over. We must learn to calmly domesticate our Beasts in those times so that we do not lose control of our vehicle. When this is achieved, we can ride wherever we please. So take good care of your Animals, and learn to understand their natures to keep everything running smoothly.

H.G. Wells:

The Island of Doctor Moreau

22. XXII. THE MAN ALONE

My trouble took the strangest form. I could not persuade myself that the men and women I met were not also another Beast People, animals half wrought into the outward image of human souls, and that they would presently begin to revert—to show first this bestial mark and then that. But I have confided my case to a strangely able man—a man who had known Moreau, and seemed half to credit my story; a mental specialist—and he has helped me mightily, though I do not expect that the terror of that island will ever altogether leave me. At most times it lies far in the back of my mind, a mere distant cloud, a memory, and a faint distrust; but there are times when the little cloud spreads until it obscures the whole sky. Then I look about me at my fellow-men; and I go in fear. I see faces, keen and bright; others dull or dangerous; others, unsteady, insincere—none that have the calm authority of a reasonable soul. I feel as though the animal was surging up through them; that presently the degradation of the Islanders will be played over again on a larger scale. I know this is an illusion; that these seeming men and women about me are indeed men and women—men and women for ever, perfectly reasonable creatures, full of human desires and tender solicitude, emancipated from instinct and the slaves of no fantastic Law—beings altogether different from the Beast

Folk. Yet I shrink from them, from their curious glances, their inquiries and assistance, and long to be away from them and alone. For that reason I live near the broad free downland, and can escape thither when this shadow is over my soul; and very sweet is the empty downland then, under the wind-swept sky.

A Witch's Bestiary © by Maja D'Aoust

978-1934170755

PROCESS

Process Media
1240 W Sims Way #124
Port Townsend WA 98368

10 9 8 7 6 5 4 3 2 1
Illustrations by Maja D'Aoust
Designed by Lissi Erwin / SplendidCorp.
The text of this book was set in P22 Vienna, P22 Pan Am,
and Plantin STD Regular